THE ART
of
EMPATHY

The Mother of Sorrows
in Northern Renaissance
Art and Devotion

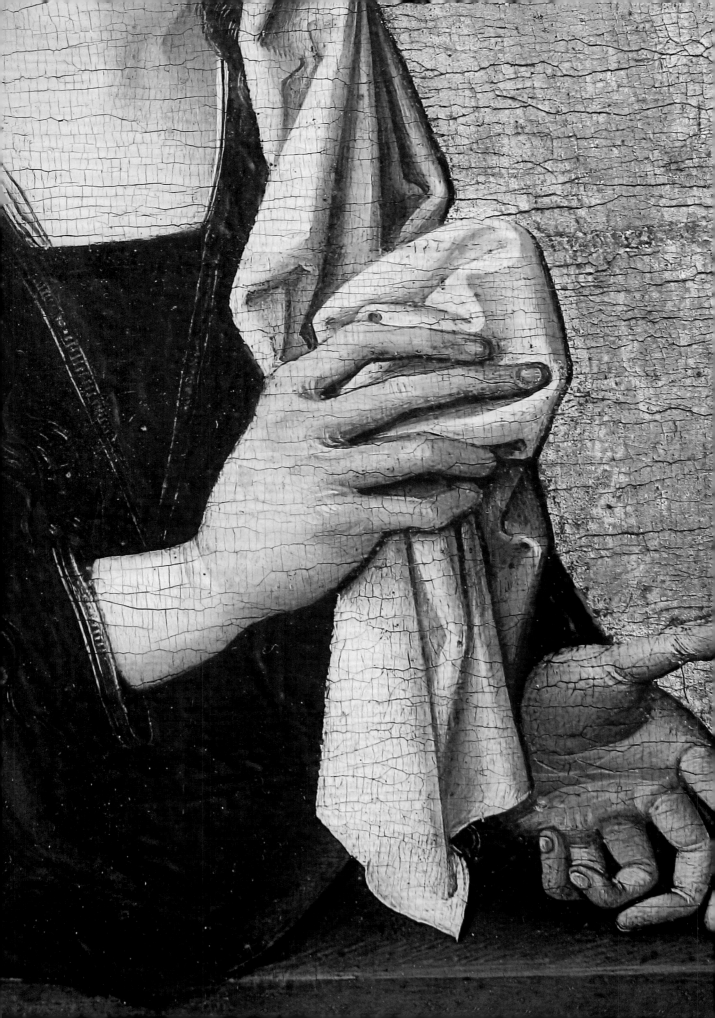

THE ART
of
EMPATHY

The Mother of Sorrows
in Northern Renaissance
Art and Devotion

David S. Areford

The Cummer Museum of Art & Gardens, Jacksonville
in association with D Giles Limited, London

This catalogue accompanies the exhibition *The Art of Empathy: The Cummer* Mother of Sorrows *in Context* at the Cummer Museum of Art & Gardens from November 26, 2013, to February 16, 2014.

First published in 2013 by GILES
An imprint of D Giles Limited
4 Crescent Stables, 139 Upper Richmond Road,
London SW15 2TN, UK
www.gilesltd.com

ISBN: 978-1-907804-26-7

For the Cummer Museum of Art & Gardens:
Project Managers/Editors: Holly Keris and Kristen Zimmerman

For D Giles Limited:
Copy-edited and proof-read by Davina Thackara
Designed by Anikst Design, London
Produced by GILES, an imprint of D Giles Limited, London
Printed and bound in China

All measurements are in inches and centimeters

Cover Images and Frontispiece: Master of the Stötteritz Altarpiece, *Mother of Sorrows*, c. 1470, oil on panel, image 8¾ × 6½ in. (22.2 × 16.5 cm). Gift of Mrs. Clifford G. Schultz in memory of Mr. Clifford G. Schultz, AG.1984.1.1. The Cummer Museum of Art & Gardens, Jacksonville, Florida. Photograph courtesy of Brian Shrum.

This project is supported in part by an award from the National Endowment for the Arts. Art Works.

ART WORKS.
arts.gov

Contents

Foreword

The Cummer Museum of Art & Gardens in Jacksonville, Florida, is regarded as one of the most significant museums in the southeast United States. Since opening in 1961, its core collection of sixty European and American paintings bequeathed by museum founders Arthur and Ninah Cummer has grown through gift and purchase. Today, it numbers nearly five thousand works of art that encompass four thousand years of art history. Committed to "engage and inspire through the arts, gardens, and education," The Cummer uses its collections and gardens as the foundation for innovative programming and thoughtful exhibitions, to create relevant, dynamic experiences for visitors of all ages. Among its holdings are impressive, massive canvases by William-Adolphe Bouguereau and Thomas Moran, majestic landscapes by John Frederick Kensett and Claude Lorrain, and powerful figural works by Giorgio Vasari and Robert Henri. However, it is an incredibly intimate and modest-sized panel painting of a weeping woman that consistently garners attention from our visitors and elicits powerful, emotional responses. The Cummer *Mother of Sorrows*, by the Master of the Stötteritz Altarpiece, is smaller than a sheet of letter-sized paper, but her impact is larger than life. Her swollen eyes and flushed cheeks communicate a grief that needs no explanation, and her unashamed emotion flows freely off the panel and into our hearts. In the following essay, David S. Areford not only examines the formal qualities of the work itself and sheds light on the circumstances surrounding its creation, but also delves into the important concept of empathy, where the viewer's emotional response helps shift experience from observer to participant. Although widely used as a devotional tool during the medieval period, the concept of empathy remains relevant in our world today.

This catalogue and its companion exhibition would not have been possible without the support of many individuals, first and foremost David Areford, whose relationship with the *Mother of Sorrows* has spanned more than a decade. Countless colleagues at other institutions helped bring this initiative to fruition, including: the National Gallery of Art, Museum of Fine Arts Boston, Walters Art Museum, Blaffer Foundation, Straus Center for Conservation at Harvard University, Davison Art Center at Wesleyan University, Munich's Staatliche Graphische Sammlung, and Aschaffenburg's Stiftsmuseum. Our friends and partners in the Department of Art and Design at the University of North Florida, Dr. Debra Murphy and Dr. P. Scott Brown, have instilled their passion for The Cummer into countless students and lifelong learners. The Cummer is also thankful for the support of the National Endowment for the Arts and their Art Works grant program. Nothing would be possible without the dedication, perseverance, and persistence of The Cummer's modest-sized yet Herculean curatorial department: Vance Shrum, Mark Warren, and Kristen Zimmerman; the unwavering guidance and vision of our Director, Hope McMath; and the limitless support of The Cummer's remarkable Board of Trustees and other community advisors.

It is with great pleasure that we share with you our beloved *Mother of Sorrows*, and we hope that she lingers long in your memories, as she has in ours.

Holly Keris, Chief Curator

Acknowledgments

The completion of this catalogue and exhibition reflects The Cummer's commitment to the scholarly investigation of its permanent collection. In this regard, I gratefully acknowledge the leadership of Hope McMath and the fine work of Holly Keris, Kristen Zimmerman, Mark Warren, and Vance Shrum. In addition, this endeavor depended on the cooperation of many individuals and institutions in the United States and Germany. Many thanks to the curators who supported this project: Achim Riether, Thomas Richter, John Oliver Hand, Clare Rogan, Martina Bagnoli, Will Noel, James Clifton, Stephanie Stepanek, and the late David P. Becker. Special thanks to Catherine Belloy, Rineke Dijkstra, Narayan Khandekar, and Teri Hensick. For advice and favors along the way, I thank Helen Evans, Jeffrey Hamburger, Elina Gertsman, Peter Parshall, Stefano Mula, Timothy Smith, and Angelo Cintron.

Research for this project was supported in part by the Dean's Research Fund at the University of Massachusetts Boston. Versions of the catalogue essay were presented in lectures at Brown University (sponsored by the programs in Medieval Studies and Renaissance and Early Modern Studies) and Florida State University (sponsored by the Vincent and Mary Agnes Thursby Visiting Scholar Lecture Series and the College of Visual Arts, Theatre, and Dance). For their support and feedback, I thank Evelyn Lincoln and Amy Remensnyder at Brown; and Stephanie Leitch, Paula Gerson, Adam Jolles, Karen Bearor, Jack Freiberg, Jean Hudson, and the graduate students of the Department of Art History at FSU.

Finally, I dedicate this catalogue to my parents, Patricia Lyons Areford and Rodney William Areford. Notwithstanding my years of formal education, they are the ones who taught me the most important lessons about art and empathy.

David S. Areford, Guest Curator

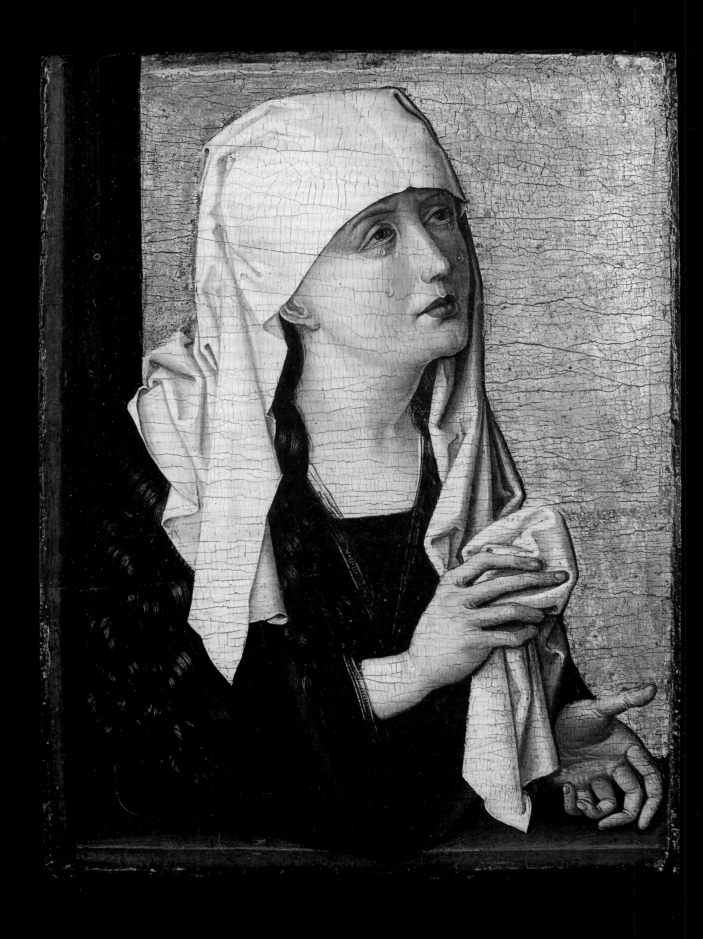

The Art of Empathy:
The Cummer *Mother of Sorrows* in Context

David S. Areford

Introduction: A Weeping Woman

The Cummer *Mother of Sorrows* is a painting that requires a special kind of attention (Fig. 1). The female subject is rendered at a doll-like scale with details that are only revealed through close looking. Once engaged, however, the viewer becomes immersed in a miniature world that seems both real and unreal in its clarity and articulation of the body and emotion. Posed against a golden background and behind a shallow ledge, the woman clutches and lifts her veil in her right hand while gently uncurling the fingers of her left. Glistening tears roll down her flushed cheeks as she gazes upward at something beyond the frame and thus beyond our view. Captured by the painter's artistry, this weeping woman is frozen not only mid-motion but also mid-*emotion*, her fraught corporeal and psychological state forever unresolved.

If we leave aside the evocative title that identifies the figure, as well as the specific religious context (explored later in this essay), and rely only on what we see, we can begin to appreciate a purposeful level of ambiguity that invites varied interpretations and levels of engagement. Confronted with the restrained gestures and tortured facial expression, each viewer must clarify the exact feelings on display by completing the scenario that has prompted the woman's response.

Fig. 1. Master of the Stötteritz Altarpiece, *Mother of Sorrows*, c. 1470, oil on panel, image 8¾ × 6½ in. (22.2 × 16.5 cm). Gift of Mrs. Clifford G. Schultz in memory of Mr. Clifford G. Schultz, AG.1984.1.1. The Cummer Museum of Art & Gardens, Jacksonville, Florida. Photograph courtesy of Brian Shrum.

Fig. 2. Rineke Dijkstra, *I See a Woman Crying (Weeping Woman)*, 2009, three-channel HD video with sound, 12 minutes, edition of 6. Photograph courtesy of the artist and Marian Goodman Gallery, New York/Paris, France.

Although created in the late fifteenth century, the painting was designed to intrigue viewers in ways that continue to interest today's artists, many of whom aim to produce spatial, corporeal, and psychological experiences that deflect meaning away from the artist and toward the audience. Indeed, the open-ended process of looking and interpreting is central to a video installation created by Rineke Dijkstra in 2009.[1] Projected on three large side-by-side screens, a video presents a group of British children as they analyze a work of art (Fig. 2). Dressed in school uniforms, the six boys and three girls are tightly framed so that we focus primarily on their faces as they look together at a painting, specifically Pablo Picasso's *Weeping Woman* from the Tate Gallery in London (Fig. 3), a work featuring a subject not

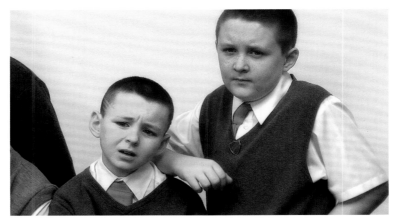

Fig. 1

Fig. 2

unlike the Cummer *Mother of Sorrows*. The painting is excluded from the video, decidedly so, in that the video is about the response to an artwork and not the artwork itself.

For twelve minutes, we watch and listen as the children contemplate the painting. After identifying the basic subject matter—one child says, "I can see a woman crying"—the group launches into a formal analysis of shapes and colors. This quickly transitions to a rapid-fire and often overlapping discussion of possible interpretations. Although one boy is initially reluctant to see beyond the formal qualities ("Maybe Picasso wanted to do a colorful picture so he drew it like that"), he and the others become truly invested in understanding the work's emotional content and potential narratives, seeking to answer the key question: "Why is she crying?" According to these young viewers, the woman appears "terrified," "petrified," and "mortified." The possibilities seem endless: "Maybe someone died in her family," "She went to a wedding and got lonely," "People are scared of her; no one wants to be her friend," or "Maybe she regrets something she's done wrong." The explanations grow increasingly elaborate: "Maybe she is a ghost" or "the living dead." The abstracted handkerchief held to the woman's face becomes an unstable element, transforming into a "love letter" or a "telegram" revealing her husband's death, or more fantastically, a soul "going into her mouth." Counter to the mainly negative storylines, the children wonder if her tears are "tears of happiness"; or perhaps "she is just mental."

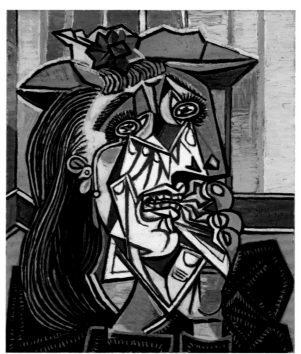

Fig. 3

Fig. 3. Pablo Picasso, *Weeping Woman*, 1937, oil on canvas, 23½ × 19¼ in. (59.7 × 48.9 cm), T05010. © Tate, London, 2013. © 2013 Estate of Pablo Picasso / Artists Rights Society (ARS), New York.

Since the video does not include Picasso's painting, we are held captive by the children's faces and voices. Thus their words are combined with facial expressions that register the often subtle and fleeting psychological and emotional effects of the artwork. Throughout the discussion, an unusually perceptive boy seated on the right seems deeply moved (Fig. 2). While he offers many contradictory explanations of what he sees, he declares with conviction: "I think she's quite lonely and afraid." At times, he mirrors the painted figure's expression, specifically her downturned mouth and furrowed brow. He even partially covers his face with his hands, a gesture that also mimics the weeping woman. His reactions seem automatic, even instinctual; he embodies the pain he sees and reflects it back at the image. This aspect of the video and its implications is highlighted in a review by Roberta Smith: "As the camera lingers over [the children's] faces, it almost seems possible to see the adult that each of them will become."[2] As demonstrated by Dijkstra's other videos and photographic series, she is especially interested in exploring the theme of childhood and the transition to adolescence and beyond. Considering the young people featured in these works, Thérèse St-Gelais writes: "Before our eyes, and quite unself-consciously, we see subjects constructing themselves—revealing themselves in the very process of self-construction."[3]

In Dijkstra's video, this process of self-construction is specifically determined by an encounter with a work of art. In other words, the artist asserts the formative nature of images, the ways in which they shape our behavior and perceptions of the world around us, particularly at crucial moments in our development. And in this case, the image inspires empathy, that is, the ability to take on the feelings and experiences of another as if they were your own (a sort of "super sympathy").[4] The word "empathy" (from the Greek *empatheia*) is a translation of the German *Einfühlung*, first used in 1873 as a term of aesthetic theory but soon appropriated by psychology.[5] In the last few years, the role of empathy has been a recurring topic of popular, political, and scholarly debate, from the confirmation hearings of Supreme Court justices to the growing concern over schoolyard bullying. In a recent *New York Times* Op-Ed column, "The Limits of Empathy," David Brooks articulates a certain level of frustration with our society's "empathy craze," as reflected in a seemingly endless stream of publications, including *The Empathy Gap*, *The Empathic Civilization*, *Teaching Empathy*, and *The Age of Empathy*.[6] In this last book, the biologist and primatologist Frans de Waal offers a persuasive argument for the innateness of empathy, summarizing an array of biological and psychological studies that suggest that human beings are hard-wired to be empathic.[7]

In light of de Waal's scientific arguments, Dijkstra's video serves as compelling anecdotal evidence. The little boy, with his sympathetic words and intense facial expressions, seems proof of the working of mirror neurons (brain cells that trigger uncontrollable responses that mirror another person's emotions) and the concept of

body mapping (the equally unconscious overlaying of another person's expressions and postures onto our own bodies).[8] While these scientific explanations are compelling, the history of art offers a more culturally determined argument. Indeed, this seems especially relevant since the schoolboy responds not to an actual suffering person but to a highly artificial image of one. Such a situation prompts many questions about the degree to which empathy is mediated—and thus defined, valued, and encouraged—as a learned behavior. How do various cultural forces (from the political to the religious) impact empathy's formation? And how do cultural products (like visual images) play a part in structuring and modeling an empathic response?

Along with Dijkstra's video, Picasso's *Weeping Woman* is a good point of departure for a discussion of art and empathy. As an image of suffering, the painting's distinctive power has long been acknowledged; and its once novel exaggerations of color and form and dramatic distortions of the human face and body are now thoroughly accepted as an appropriate vehicle for expressing emotion and pain. Even the young children in Dijkstra's video understand the goals of such a visual language. One observes that the artist "paints how people feel"; and another correlates the formal pyrotechnics with "how it would feel on the inside."

Picasso's painting is one of a series of paintings, drawings, and prints in which he explores the theme of the crying woman.[9] Each varies in gesture and pose, as well as in formal and expressive intensity, as demonstrated by *Weeping Woman with Handkerchief* in Madrid's Museo Reina Sofia (Fig. 4). All of these works were produced in 1937 in connection with *Guernica*, the mural-sized painting named for the Basque town bombed during the Spanish Civil War. Though clearly linked to this famous image of the atrocities of war, Picasso's weeping women must also be understood in terms of his biography, specifically his strained relationships with his wife Olga Koklova and mistresses Marie-Thérèse Walter and Dora Maar. In short, these images can be understood as both personal and universal statements. In art historical terms, their origins are found in the quintessential weeping woman—the Virgin Mary as *Mater dolorosa*, or Mother of Sorrows. The artist was undoubtedly influenced by the tradition of the sorrowful Virgin in Spanish art, especially in sixteenth- and seventeenth-century painting and sculpture.[10] His weeping women are transformations of the sacred subject matter into personal and political terms, while maintaining the elemental power of a mother grieving the loss of her child.

Besides their subject matter, Picasso's paintings may seem far removed from the Cummer *Mother of Sorrows*. Yet a comparison, especially between the Cummer panel and the Madrid painting, is instructive. There are a number of surprising similarities in terms of composition, pose, clothing, and the crumpled handker-

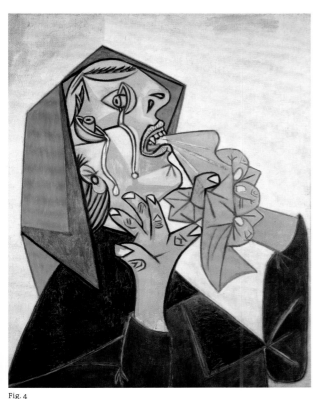

Fig. 4

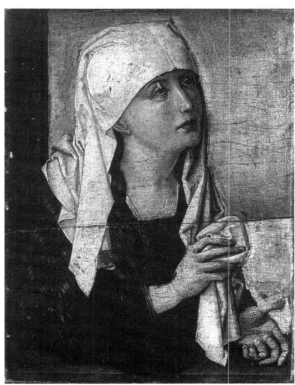

Fig. 5

Fig. 4. Pablo Picasso, *Weeping Woman with Handkerchief*, 1937, oil on canvas, 36¼ × 28¾ in. (92 × 73 cm), DE00106. Archivo fotográfico Museo Nacional Centro de Arte Reina Sofía, Madrid, Spain. © 2013 Estate of Pablo Picasso / Artists Rights Society (ARS), New York.

Fig. 5. Pre-restoration photograph (before 1983), Fig. 1.

chief, as well as the facial expression, gesturing hands, and streaming tears. Of course, the differences—especially in form and style—are equally interesting, in that they highlight the contrast between the aesthetic aims of twentieth-century modernism and those of a late medieval world in which images served a very different function. Although more modest and understated, the *Mother of Sorrows* was just as carefully designed to move viewers in profound ways. When appreciated on its own terms, this crying woman allows us to explore not only a particular artistic and religious context but also the essential role of images in how we define our humanity.

A Painting (and Artist), Lost and Found

Prior to 1983, when it was offered for sale at a New York gallery, the Cummer *Mother of Sorrows* was unknown to art history.[11] The fact that it survives at all is remarkable, especially in light of its condition when rediscovered. Painted in oil with gilding on a wooden panel measuring only 9 × 6¹¹⁄₁₆ inches (22.9 × 17 cm), the work was inherently vulnerable. While the circumstances of its discovery are a mystery, the panel's compromised physical state was well documented in a black-and-white photograph (Fig. 5).[12] Most noticeably, the photograph shows a deep horizontal crack through the panel's middle. This damage clearly caused the wood to split and may have even completely broken the panel in two. Also evident are many areas of paint loss, layers of grime, and a network of fine cracks (*craquelure*)—caused by age and extreme relative humidity changes—that radiate across the entire surface.

Except for these cracks, the painting is now beautifully restored (Fig. 1). However, the full extent of its once fragile state is confirmed by an x-radiograph, which

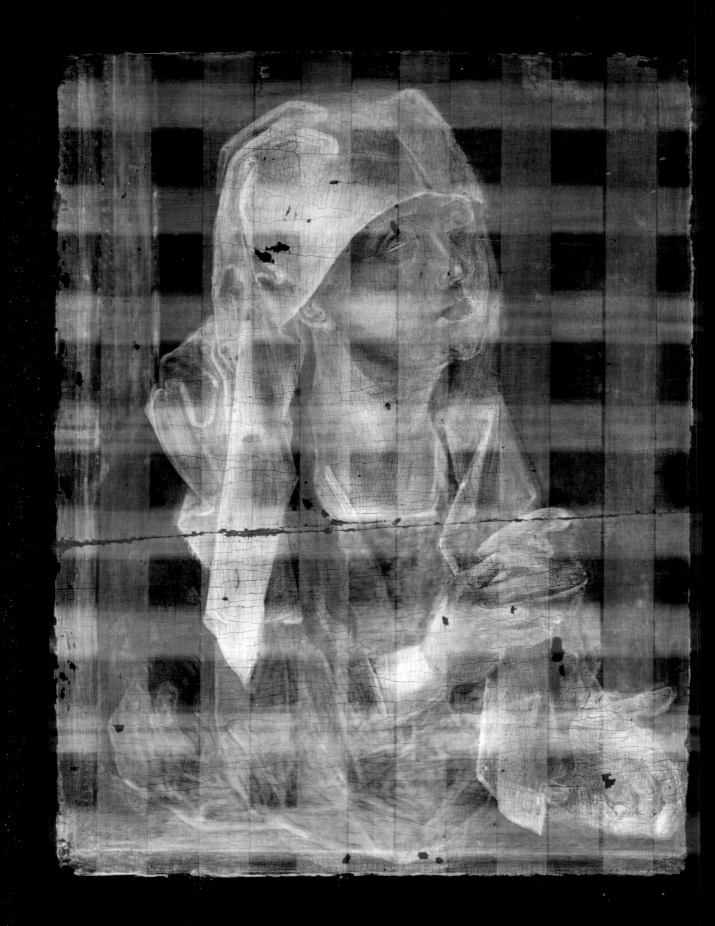

Fig. 6. X-radiograph, Fig 1.

allows a view through the layers of paint, as well as the panel itself (Fig. 6). The x-ray gives a more complete picture of the missing bits of original paint and underlying ground layers. These are indicated by dark patches—along the large crack, as well as over one eye and on the veil, hands, and elsewhere—filled in during one or more restoration treatments. The ghostly grid pattern represents the matrix of wood strips (a cradle) that was attached to the reverse during restoration in order to stabilize the panel while still allowing it to expand and contract. At the same time, the panel was probably thinned to its current thickness of $3/16$ of an inch (0.5 cm), thus removing its original back surface. For all the damage it reveals, the x-ray also confirms that the painting survives basically unaltered and in a complete state, that is, not cut from a larger composition. This is proven by the accumulated ridge of ground and paint layers (a barbe) that appear white at the x-ray's outer edges, marking the intersection of an engaged frame that is long lost.

The x-ray's revelations, along with the findings of several other scientific methods of analysis, help recreate the steps in the painting's production.[13] As was typical, the artist began with the plain wooden panel and frame joined together as one unit. Although his choice of a poplar panel—instead of a harder wood such as oak—was unusual for northern Europe, his procedure was otherwise quite standard. First, the panel and engaged frame were covered with gesso—a mixture of natural chalk, water, and a binder (usually rabbit-skin glue)—applied in several coats. The picture area was then smoothed to create a perfectly flat surface. Before proceeding, the artist may have painted the attached frame. This is suggested by the presence of a layer of vermilion mixed with lead white near the panel's edges, perhaps an inadvertent spillover indicating that the original frame was colored, in full or in part, with a light pink.[14]

With the picture surface prepared, the artist sketched the figure, likely basing his design on a model drawing. Using infrared-reflectography, we can still see parts of his sketch, especially the bold contour lines indicating the form of the veil and bodice. After determining the composition's key elements, the artist prepared the panel for gilding. The areas around the drawn figure were covered with a bole consisting of red clay combined with vermilion. The gold was then applied in thin sheets that allowed the bole to show through, thus intensifying the golden color and its radiant effect, especially after the final step of burnishing the metal to a high gloss. With the shimmering background complete, the artist began the time-consuming work of painting the figure, mixing mainly mineral pigments with linseed oil and applying layers of color that varied from opaque to translucent. Microscopic analysis of the figure's blue mantle demonstrates that its rich color is the result of a thin coat of vermilion between two layers of azurite, a combination simulating the appearance of the more expensive ultramarine, made from lapis lazuli. This cheaper substitute suggests that the artist was perhaps working for a client of relatively modest means.

Fig. 6

At the time of its sale, Colin Eisler attributed the Cummer panel to the little-known Master of the Stötteritz Altarpiece, an artist who trained in Nuremberg and was active in Germany during the late fifteenth century. Yet beyond this convincing attribution, the painting has received little scholarly attention.[15] The anonymous master is named for his most significant surviving work: a triptych in the parish church of St. Mary in Leipzig-Stötteritz, just outside of Leipzig (Fig. 7).[16] This altarpiece was likely produced in Nuremberg, where it remained until the early eighteenth century when it was acquired for the newly built church in Leipzig-Stötteritz by Eucharius Gottlieb Ringk, a leading citizen and university professor.[17] The triptych's central panel features a detailed Crucifixion flanked by scenes of the Agony in the Garden and the Resurrection on the wings.[18] The work is clearly by an artist at the height of his powers. Especially impressive is the way in which all three scenes are integrated in terms of their landscape setting and yet each expresses a different temporal moment indicated by varied light effects—the cloudy night sky in the garden, the spectacular sunset at Golgotha, and the moment just before dawn at Christ's tomb. Compared to earlier German painting, such subtle and realistic representations of light and atmosphere are unprecedented. Also noteworthy is the general harmony of composition and color, along with an incredible restraint in the depiction of poses and facial expressions. Although the cross is surrounded by seventeen figures—gesturing, talking, and crying—there is an overall sense of profound stillness (Fig. 8).

Fig. 7. Master of the Stötteritz Altarpiece, *Crucifixion Triptych*, c. 1470, oil on panel, center 49⅝ × 43¹¹⁄₁₆ in. (126 × 111 cm) and wings 49⅝ × 17¹⁵⁄₁₆ in. (126 × 45.5 cm). Lutheran Marienkirche, Leipzig-Stötteritz, Germany. Photograph courtesy of the Parish.

Fig. 8. Center panel, Fig. 7.

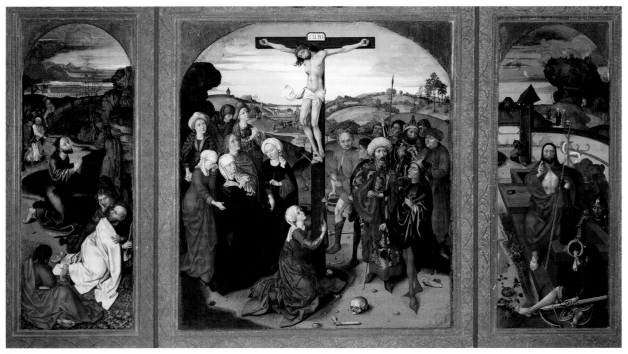

Fig. 7

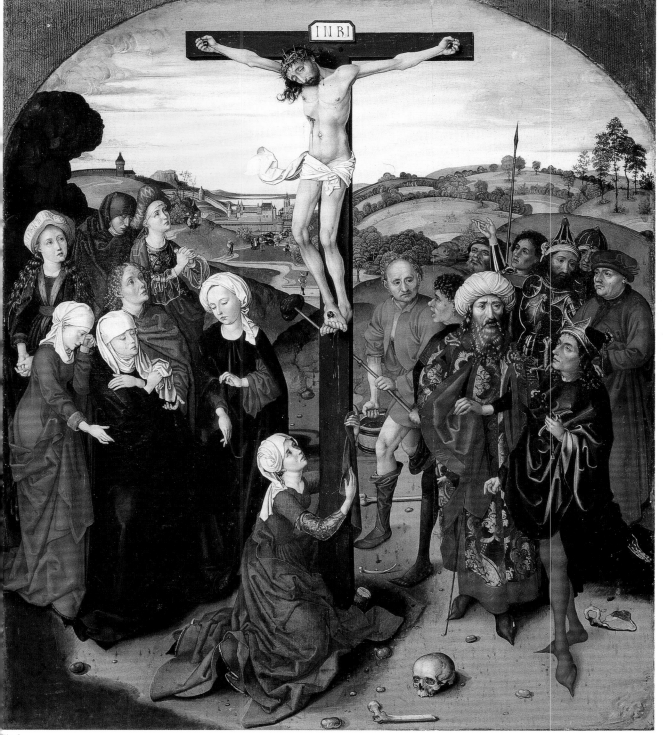

Fig. 8

In 1997, Fedja Anzelewsky specifically linked the Cummer *Mother of Sorrows* to the figure of the Virgin Mary in the Stötteritz altarpiece.[19] Besides sharing stylistic and formal qualities, both figures are depicted weeping and dressed in a similar white head covering, part of which is held in their hands. However, in the Cummer painting, Mary's pose is markedly different from her counterpart in the altarpiece, in that she looks up and both hands extend from her body. Her veil functions in a different way as well, hanging loose and exposing her neck and hair, a contrast to the tightly wrapped cloth that conceals all but the face in the altarpiece. Also, instead of obscuring her hand, the fabric is gathered so that most of her fingers are visible. This particular difference is striking, yet the recent infrared-reflectography of the panel shows that the artist initially planned to follow the altarpiece's example. In the revealed underdrawing (just visible beneath the paint layers), the veil is sketched so that it falls over Mary's knuckles and almost covers her entire hand (Fig. 9).

Although obviously related to the altarpiece's Virgin Mary, the Cummer *Mother of Sorrows* is most similar in pose and facial features to a woman standing behind the Virgin and John the Evangelist (Figs. 8 and 10). Wearing a red and gold turban and a luxurious gown of green and gold brocade with diaphanous outer sleeves, this exotic figure probably represents one of the pagan sibyls who predicted Christ's crucifixion.[20] In a side-by-side comparison, the sibyl and the sorrowful Mary share almost identical faces and head positions, as well as very similar hands (Figs. 10 and 11) Indeed, they are even depicted at the same exact scale, which indicates the existence of a model drawing that was used to sketch both figures. Created originally for

Fig. 9

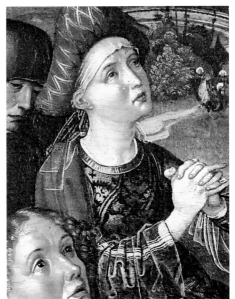

Fig. 10

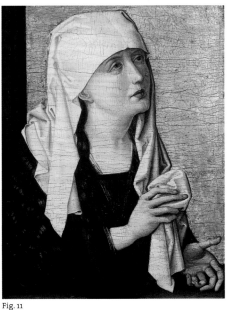

Fig. 11

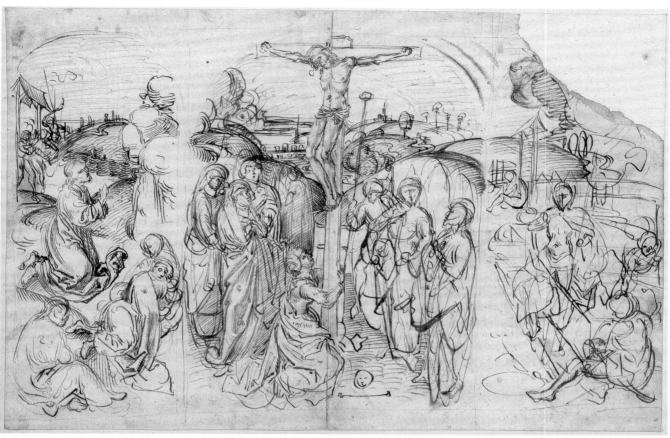

Fig. 12

Fig. 9. Infrared-reflectograph,
Fig. 1 (detail).

Fig. 10. Center panel, Fig. 7
(detail).

Fig. 11. See Fig. 1.

Fig. 12. Master of the Stötteritz
Altarpiece, *Study for a Crucifixion
Triptych*, c. 1470, pen and brown
ink on paper, 8¼ × 12⅜ in.
(21 × 31.5 cm), KdZ 1031. bpk,
Berlin, Kupferstichkabinett,
Staatliche Museen, Berlin,
Germany / Art Resource, NY.
Photograph courtesy of
Jörg P. Anders.

the altarpiece, this now-lost drawing provided a perfect template for the Virgin Mary in the panel. Its reuse sheds light not only on specific practices within the master's workshop but also indicates a close chronological link in the production of the *Mother of Sorrows* and the triptych.

In addition to the altarpiece and the Cummer panel, the Stötteritz Master is known only through three drawings. These include a preparatory sketch for the Stötteritz triptych, preserved in Berlin and noteworthy as the earliest surviving design for an altarpiece in northern Europe (Fig. 12).[21] Unlike other contemporaneous German drawings, it is primarily a compositional study and, as such, it provides a rare glimpse of an artist's decision-making process in the early stages of a commission. Instead of a finished study made for a client's approval, the sketch was probably meant for the artist's use only. It records the working-out of the overall composition along with the placement of key components and even the shape of the frames. In addition, some aspects of volume, space, and light are indicated (mainly on the left where shading is more complete), and the artist has already made some important color choices. In the scene of the Agony, the garments of James and Peter are labeled, respectively, "R" for *rot* (red) and "W" for *weiss* (white); and in the center, the kneeling Mary Magdalene's voluminous dress is inscribed "*grien*" (green).

Also related to the Stötteritz triptych is a second sketch, now in Budapest, which was likely produced before the Berlin drawing (Fig. 13).[22] This offers an earlier, alternative version of the central Crucifixion and is, for the most part, a thoroughly different conception of the scene, with a vertical format and a cross much higher and

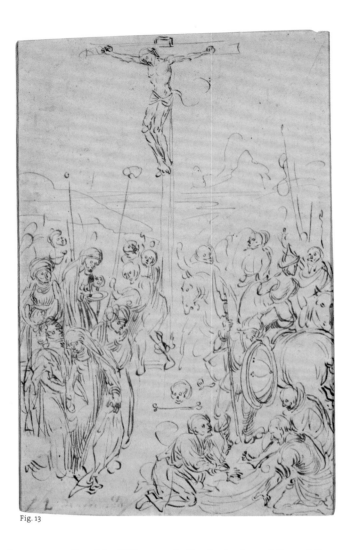

Fig. 13

farther back in space. The most noticeable difference is the inclusion of the soldiers gambling over the Savior's seamless garment. Yet the drawing's relationship to the triptych is made clear by a figure at the left edge: a woman wearing a turban, who clasps her hands together and looks back at Christ over her shoulder. While the Berlin drawing does not include this enigmatic figure, she is quite prominent in the finished altarpiece, where she wears a strange, layered hat (Fig. 8).

A third and final drawing attributed to the Stötteritz Master survives in the library collection of the University of Erlangen and offers yet another variation of the events at Golgotha, although a much more polished one (Fig. 14).[23] In this case, the scene consists of only three figures, with the Virgin Mary and John the Evangelist on either side of Christ. The isolated and mournful Virgin is undoubtedly connected to the figure of the *Mother of Sorrows* in both its details and overall conception (Fig. 1). As in the painting, Mary's head is depicted in a three-quarter view as she gazes upward at her son. Her face shares the same furrowed brow, long nose, small mouth, and weak chin. The folds and creases of her headscarf are also remarkably similar, as are her hands with their overly long fingers. Although different in scale and medium, the drawing and painting are creations of the same artistic imagination, offering closely related physical and psychological portraits of the Virgin Mary beneath the cross. The subdued gestures of each figure seem part of one sequence of

Fig. 13. Master of the Stötteritz Altarpiece, *Study for Calvary*, c. 1470, ink on paper, 6⁵⁄₁₆ × 4 in. (16 × 10.1 cm), Inv. Nr. 2. Szépmüvészeti Múzeum, Budapest, Hungary.

Fig. 14. Master of the Stötteritz Altarpiece, *Christ on the Cross between Mary and John the Evangelist*, c. 1465–1470, pen and brown ink on paper, 12⅜ × 8¼ in. (31.4 × 21 cm), B59. Graphische Sammlung, Universitätsbibliothek, Erlangen, Germany.

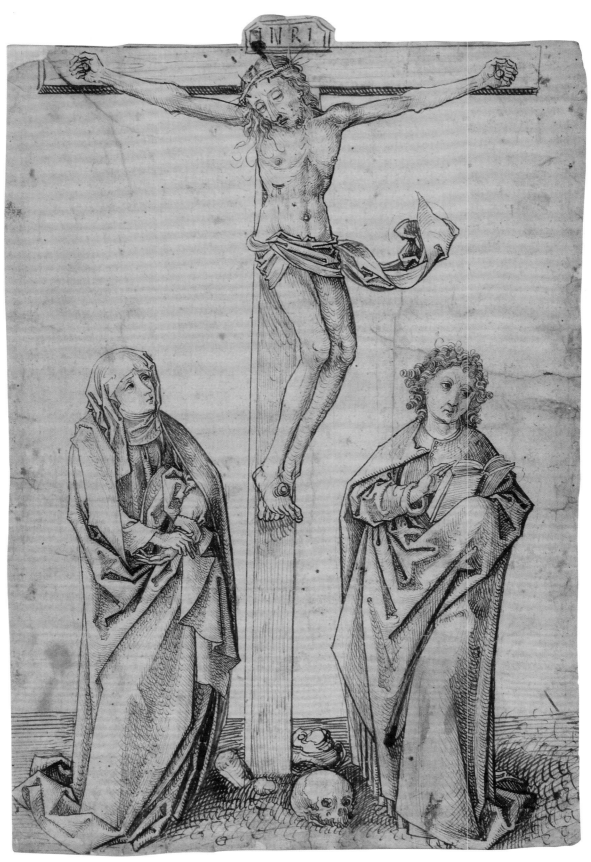

Fig. 14

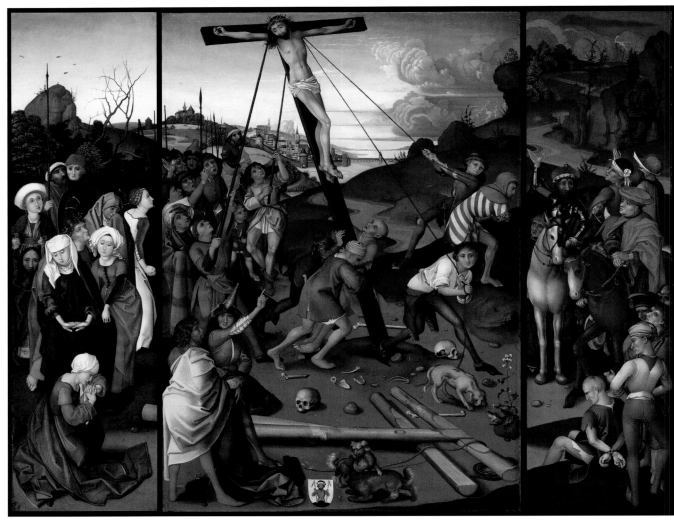

Fig. 15

movement. One can easily imagine the drawing's Virgin extending her left hand while lifting her right to uncover her neck and hair, thus gathering the veil in her fingers as she does in the painting.

Although the Stötteritz Master is known only through these few surviving works, scholars have a fairly certain understanding of his origins, training, and the years of his production. Of course, the finished altarpiece provides the best evidence in this regard. Its style and iconographic motifs are characteristic of an artist trained in Nuremberg in the circle of Hans Pleydenwurff, one of the city's most successful artists.[24] He may have been an apprentice in Pleydenwurff's large workshop, which was taken over by Michael Wolgemut after the master's death in 1472. Several figures in the Stötteritz triptych are clearly derived from Pleydenwurff's altarpiece of 1465 made for Saint Michael's Church in Hof.[25] These include the central panel's holy women and John the Evangelist, as well as the left wing's apostle seen from behind and the right wing's resurrected Christ. The Hof altarpiece's influence is also reflected in the work of another anonymous Nuremberg artist, the Master of the Starck Triptych, named for his only known painting now in the National Gallery of Art in Washington (Fig. 15).[26] This triptych, which bears the Starck family coat of arms, also depends on the Stötteritz altarpiece. Aspects of landscape and lighting

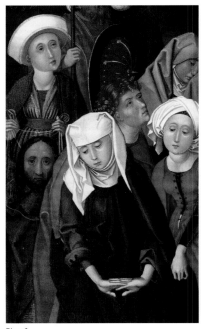

Fig. 16

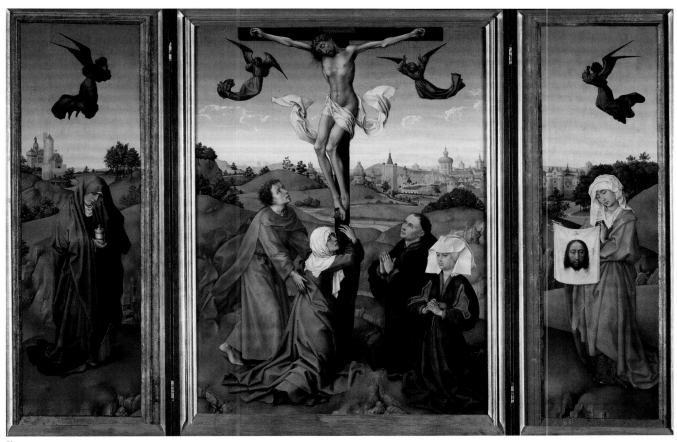

Fig. 17

are quite similar, as are several figures gathered below the cross, especially the woman standing at the left wing's outer edge (Fig. 16). As already mentioned, this figure is found in both the Stötteritz altarpiece and the Budapest drawing of the Crucifixion. In this case, she takes on a definite identity as Saint Veronica holding a cloth imprinted with an image of Christ's face.

The Starck Master and the Stötteritz Master were obviously part of the same artistic milieu, and it is likely that their years of training overlapped. Based on Pleydenwurff's example, they perfected not only the typical features of Franconian painting but also gained a thorough knowledge of contemporary Netherlandish art (which Pleydenwurff knew firsthand). This manifests itself in the poses, gestures, and clothing appropriated from paintings by Rogier van der Weyden and others.[27] The woman looking back over her shoulder, for instance, originated in a *Crucifixion*, c. 1429, by Rogier or his workshop.[28] Another *Crucifixion*—a triptych in Vienna and dated c. 1445 (Fig. 17)—is the source for several other figures in the Stötteritz altarpiece: the upward gazing John the Evangelist, the woman clad in a blue mantle in the background (also in the Starck triptych), and the kneeling Mary Magdalene who dramatically embraces the cross (Fig. 8).[29] Even Christ's fluttering loincloth is ultimately indebted to Rogier's influence. Of course, the use of these models was more

than simply a creative shortcut. The Stötteritz Master was also interested in emulating the realism and theatricality of Netherlandish art, along with its heightened, yet restrained, emotional mood. These goals are represented perfectly by the woman who supports the Virgin and wipes away tears with the back of her hand (Fig. 8). This touching gesture can be traced to a weeping angel in the *Entombment Triptych*, c. 1425, by the Master of Flémalle, or Robert Campin, who was Rogier's teacher and perhaps the first artist to depict painted tears.[30]

Based on comparisons with other Nuremberg paintings with sure production dates, the Stötteritz altarpiece can now be dated with some accuracy. As discussed, the artist borrowed quite a bit from Pleydenwurff's Hof altarpiece of 1465. In addition, there are paintings that rely on the Stötteritz triptych for their compositions and figure types.[31] The sleeping James, Peter, and John in the left wing's *Agony in the Garden*, for example, are copied almost verbatim in the wall painting memorial to Hans Starck produced soon after his death in 1473 for St. Sebald's Church in Nuremberg.[32] The figure of Peter is also the apparent model for his counterpart in a painting by Gerard Weger for the Church of St. Catherine in Brandenburg, inscribed 1474.[33] The Erlangen drawing also helps to narrow the possible timeframe; the paper on which it was executed bears a watermark similar to several examples dating 1465 to 1468.[34] Thus the evidence would suggest that the Stötteritz triptych was produced sometime between 1465 and 1473. Since the *Mother of Sorrows* is so clearly dependent on the triptych—from the use of the same preparatory drawing to the style of its painted features—its creation was very close in time. Therefore, an approximate date of c. 1470 seems reasonable for both the triptych and the Cummer panel.

With this more precise understanding of the Stötteritz Master's training and period of activity, scholars are better positioned to assess his relationship to artistic contemporaries, not only Nuremberg painters but other German artists such as Martin Schongauer, the famous painter and printmaker of Colmar. In the past, when the Stötteritz altarpiece was variously dated to around 1480 or even 1490, its style and figure types were thought to reflect Schongauer's influence. But considering the altarpiece's new earlier dating, the connection between these artists must be reevaluated.[35] In 2004, Stephan Kemperdick argued that Schongauer may have traveled to Nuremberg in the late 1460s, perhaps even training with Hans Pleydenwurff.[36] If true, then he certainly crossed paths with the Stötteritz Master; he may have even spent his apprenticeship alongside him. Moreover, it is currently thought that Schongauer settled in Colmar and began creating his well-known engravings no earlier than 1470.[37] Thus, based on this timeline, it is more likely that Schongauer's work emulates the style and motifs perfected by the Stötteritz Master and other Nuremberg artists. In this regard, the drawings in Berlin and Erlangen—with their use of cross- and parallel hatching mixed with a distinctive hooked line—serve as crucial evidence of the Stötteritz Master's innovative technique, an approach to

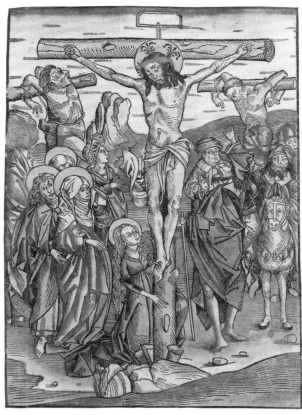

Fig. 18

drawing that not only influenced Schongauer but had a broader impact through its dissemination in his prints.[38] In this revised art history, the anonymous German master proves to be a key figure, whose work bridges the late Middle Ages and Renaissance in the north, preparing the way for the art of Albrecht Dürer. With this trajectory in mind, Kemperdick recently declared that the Master of the Stötteritz Altarpiece "must certainly be ranked among the outstanding artists of his time."[39]

Beneath the Cross: Experiencing the Passion

The Virgin Mary's presence at the Crucifixion is mentioned only in the Gospel of John and with very little detail: "Now there stood by the cross of Jesus, his mother…" (19:25). These few words are the scriptural source for countless depictions of the Virgin beneath the cross mourning her son's torture and death. As demonstrated by the Stötteritz Master's known works, this sorrowful mother also represents the artistic and iconographic origins of the woman in the Cummer panel. By the fifteenth century, the basic elements of the Crucifixion scene, as well as its typical compositional and thematic structure, were well established. In a 1491 edition of Stephan Fridolin's *Schatzbehalter*, a book of Passion meditations, a woodcut *Crucifixion* exhibits standard poses, gestures, and clusters of figures (Fig. 18).[40] An oppositional divide between the mainly female followers of Christ, on one side, and the male antagonists and gawkers, on the other, is reinforced by the addition of two crucified thieves. Like the downcast eyes of the Bad Thief, the men on Christ's left are primarily unreceptive, lost in argument, mocking, and gestures of speech; while on the Savior's right, the receptive, upward gaze of the Good Thief matches

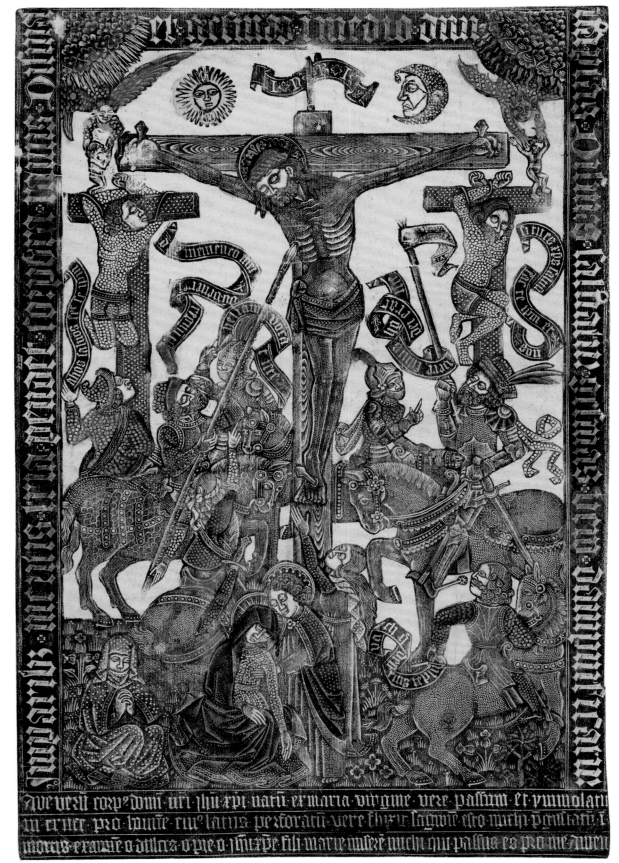

Fig. 19

Fig. 19. Master of the Aachen Madonna, *Crucifixion*, c. 1460, colored metalcut, image 15^{11}⁄₁₆ × 10^{9}⁄₁₆ in. (39.8 × 26.8 cm). 1951 Purchase Fund, 51.699. Museum of Fine Arts, Boston, Massachusetts.

the deeply emotional and physical response of the figures below. As in the Stötteritz altarpiece, Mary Magdalene embraces the cross and the Virgin Mary lifts her veil, although here she emphatically looks at Christ and wipes away her tears.

Such a clear, bilateral arrangement is absent in another version of the subject: a spectacularly detailed metalcut, c. 1460, produced perhaps in southern Germany (Fig. 19).[41] In this case, the witnesses to the Crucifixion circle around the central cross, many of their responses clarified by inscribed banderoles that give them voices. These Latin texts are abbreviated verses from the Gospel of Matthew.[42] On the lower right, a mounted soldier taunts Jesus: "Vah, thou that destroyest the temple of God, and in three days dost rebuilt it: save thy own self: if thou be the Son of God, come down from the cross" (27:40). The rider on the far left is equally dismissive: "He saved others; himself he cannot save" (27:42). These mockers of Christ are opposed by the Good Centurion, conspicuously positioned center right, dressed in armor and a feathered cap and also on horseback. Looking up at Jesus, this man is convinced by what has transpired, his words curling around his lance: "Indeed this man was the son of God" (27:54). His positive reaction is paralleled on the left by the soldier piercing Christ's side. Mentioned only in John's Gospel (19:34–35), he is later called Longinus in apocryphal accounts that also add that he was almost blind, which explains the man helping him aim his weapon.[43] In this case, words are replaced by Longinus's gesture toward his faulty eyes, a hint of a miracle about to occur: the healing of his sight by drops of Christ's blood. With his ability to see restored, Longinus gains access to a deeper, spiritual vision and becomes a follower of Jesus.

These contrasting reactions are articulated as well by the two thieves. Although they are shown dead, their fateful words from Luke's Gospel (23:39–43) unfurl beside them like lingering echoes. Next to the Bad Thief, whose twisted body turns away from Jesus, the scroll demands: "If thou be Christ, save thyself and us." The Good Thief's scroll records his faithful request: "Lord, remember me when thou shalt come into thy kingdom." To which Jesus replied: "Amen I say to thee, this day thou shalt be with me in paradise." The thieves' just rewards are visualized by tiny naked souls, one kneeling in prayer and carried to heaven by an angel and the other struggling to escape a green demon's talons and the fires of hell.[44] In addition, the bold, multicolored Latin inscription, along the top and sides, spells out their fates, using their traditional names: "Unequal in their merits, three bodies hang on the tree, Dismas and Gesmas and in the middle God's might. Dismas is saved, Gesmas is truly damned."[45] By framing the entire scene, the text focuses attention on the thieves and their dramatic encounter with Jesus. But the inscription's prominence is explained as well by its late medieval use as a charm that protected against physical suffering, specifically for prisoners facing torture, as well as for anyone dealing with bodily pain.[46] Thus the metalcut is much more than a biblical illustration. It is

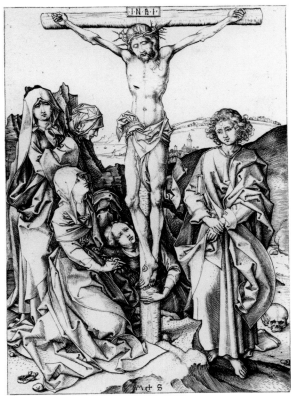

Fig. 20

also an instrument of magical efficacy that extends the triumphant power of the crucified Christ over suffering and death and, more broadly, over evil forces, signified by the bat-like demon, as well as by a scorpion on the banner attached to the centurion's spear.[47]

Beyond these potential functions, a three-line inscription below the image reveals another level of meaning, one that is more communal and liturgical. The Latin text is a highly abbreviated version of a popular Eucharistic prayer, *Ave verum corpus (Hail true body)*, attributed to Pope Innocent VI (1352–62).[48] Often included in devotional manuscripts, such as books of hours, this short prayer was recited by the laity as they adored the consecrated Host as the "true body" of Christ. As a caption for the Crucifixion, the text clarifies the link between the events of Golgotha and those at the altar: "Hail, true body born of the Virgin Mary, you who have truly suffered and been sacrificed on the cross for man. You from whose pierced side water and blood flowed, in the ordeal test of death be for us a foretaste of heaven."[49] The standard prayer is appended with a personalized plea: "O dear, merciful Jesus Christ, son of Mary, have mercy on me, [you] who suffered for me. Amen."[50] The references to Christ's human lineage—"born of the Virgin Mary" and "son of Mary"—acknowledge the Virgin's crucial role in the Incarnation, her repeated name fittingly on the central axis with the cross above.

Ultimately, the metalcut's combination of text and image served multiple functions: narrative, devotional, apotropaic, and liturgical. But the print also offered didactic models of response for the medieval audience. As the first person saved by Christ's death on the cross, Dismas becomes an exemplar of confession and penance. And the Good Centurion and Longinus serve as perfect representatives of

Fig. 20. Martin Schongauer, *Crucifixion*, c. 1480–1490, engraving, image 6⁷⁄₁₆ × 4½ in. (16.3 × 11.5 cm), 140906 D. Staatliche Graphische Sammlung, Munich, Germany.

faith and conversion. Situated in the foreground, the Virgin Mary reacts to the horror of the Crucifixion as only a mother could. Diverting from John's account, she has collapsed, mentally and physically drained. As an extreme model of empathic response, she has taken on her son's suffering as if it were her own.[51]

The Crucifixion is given a much more refined and intimate treatment in an engraving by Martin Schongauer (Fig. 20).[52] Focused only on Christ's closest followers, the print is a nuanced study of different modes of emotional and psychological engagement, explored not only through their somber facial expressions but also through gestures, postures, and the direction and intensity of their gazes. The sideward glance of John, who stands alone and reserved on the right, guides us to the five women on the left, a group that visually merges as if one body simultaneously expressing a full range of emotions. Foremost among them is the Virgin, who kneels and looks up at the lifeless Jesus. Her head position, along with details of her face, veil, and exposed neck, reveal a definite connection to the Cummer *Mother of Sorrows* (Fig. 1). The depth of her feelings is communicated by her knotted brow and intertwined fingers, less a gesture of prayer than of distress. Embracing the base of the cross and gazing upward, Mary Magdalene is the most physically unrestrained, while the women behind her can no longer even bear to look. One covers her entire face, except for her crying eyes; one bows her head, lost in private introspection; and the final figure stares outward, thus making clear that this circuit of response begins and ends with the viewer.

In the late Middle Ages, the devotional goal of immersing oneself in the Passion was fostered by the development of new images that went well beyond the biblical accounts. A hand-colored woodcut of the Lamentation, signed by Michel of Ulm, offers an imagined scene following the Crucifixion (Fig. 21).[53] Beneath the empty cross, arrayed with several *arma Christi* or Instruments of the Passion, the Virgin, John, and Mary Magdalene (with a fifteenth-century layman in the background) kneel beside the Savior's almost naked corpse streaked with blood. Their collective grief is most evident in the gesture of the beloved apostle, who lifts his red cloak to dry his tears. Christ's upturned head lies on his mother's lap as she stares down vacantly with her hands clasped in prayer. Her stoic pose is belied by the German xylographic inscription, a version of a fourteenth-century anonymous lament written in the Virgin's voice and addressed to Christ. It begins with a series of metaphors: "O flowing well of eternity, how you have run dry. O wise teacher of humanity, how you have been silenced. O splendor of sunlight, eternal light, how you have been extinguished. O abundant wealth, how you shine amid great poverty. O joyous gladness, how your countenance is full of sorrow." The text concludes with a moving *cri de cœur*: "O dear child, if I knew not in my soul whom you were, you would be a stranger to me. O dear child in my soul how you have been tortured and wretchedly put to death for me."[54]

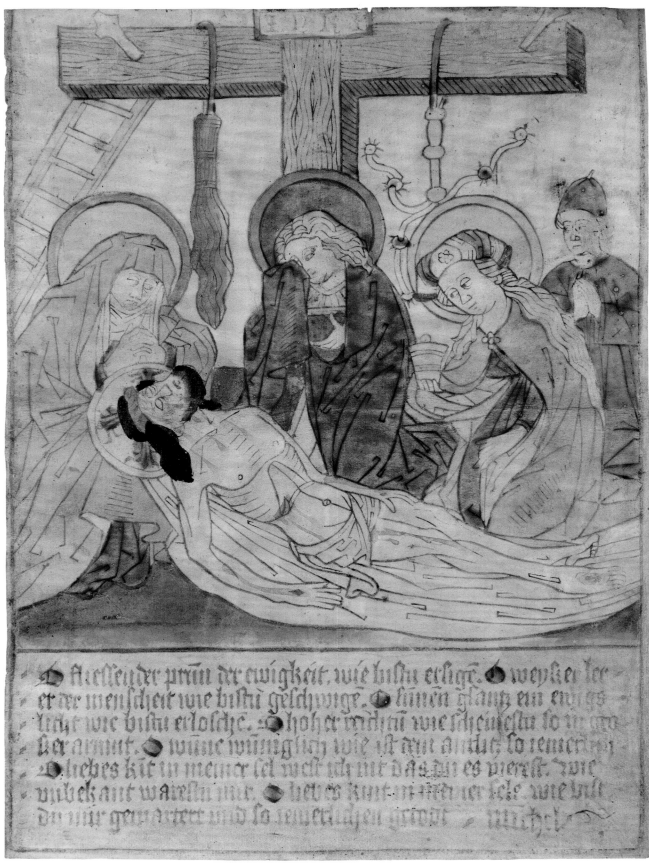

Fliessender prun der ewigkeit. wie bistu ersiget. ❧ weyst er ler
er der menscheit wie bistu geschwige. ❧ hinen glantz ein ewigs
licht wie bistu erlosche. ❧ hoh er wirdiru wie scheineste so vil gro
ser armut. ❧ wunie wunglich wie ist dein andlit so reuterlich
❧ liebes kit in meiner sel west ich nit das du es pierest. wie
vnbekant warestu mir. ❧ heb es kint in meiner sele wie bist
du mir getarteer und so reuerlichen getrat ❧ michel

Fig. 21

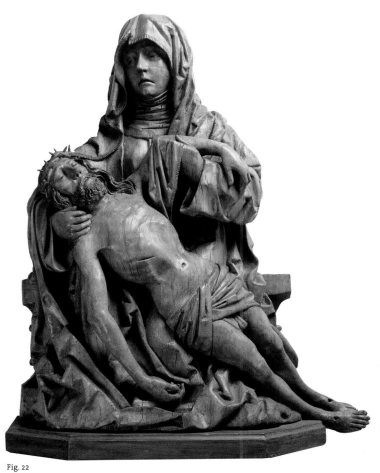

Fig. 22

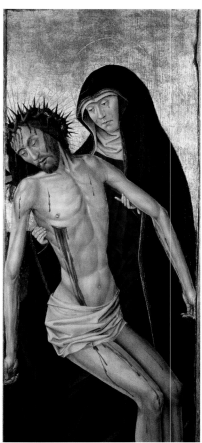

Fig. 23

Fig. 21. Michel of Ulm, *The Lamentation with the Virgin, John, Mary Magdalene, and a Witness,* c. 1465–1475, colored woodcut, image 14¹¹⁄₁₆ × 10¾ in. (37.3 × 27.3 cm). William Francis Warden Fund, 53.359. Museum of Fine Arts, Boston, Massachusetts.

Fig. 22. Peter Breuer, *Pietà,* c. 1490, limewood, 35 × 29¼ × 12 in. (88.9 × 74.3 × 30.5 cm). Purchased with funds from The Cummer Council, AP.1982.1.1. The Cummer Museum of Art & Gardens, Jacksonville, Florida.

Fig. 23. School of Picardy, *Pietà,* c. 1460–1470, oil on panel, 29¼ × 12 in. (74.3 × 30.5 cm), 1991.22. Sarah Campbell Blaffer Foundation, Houston, Texas.

Some of the most powerful visual expressions of the Virgin Mary's sorrow are found in a type of Lamentation known by the Italian term pietà or the German *Vesperbild.* [55] These images focus only on the dead Christ and his mother, as in a late fifteenth-century limewood sculpture attributed to Peter Breuer of Zwickau (Fig. 22). [56] Like other German examples, Mary is noticeably larger than Jesus, a way of literalizing her memory of him as a child. Her intensely personal experience becomes our own, as she lifts her veil to wipe her tears or perhaps to clean her son's tortured limbs. Even without the realism of color, the monochromatic sculpture's three-dimensionality and inviting tactility are fully exploited; the wounded feet, awkwardly hanging off the plinth, especially encourage pious touching. Christ's body is also made vividly accessible in a fragmentary painted *Pietà,* c. 1460–1470, by an anonymous French artist (Fig. 23). [57] Experienced up close, the Virgin's streaming tears and the thick flow of blood from Christ's side wound appear wet and tangible, as if they might actually drip from the panel's surface.

The intimacy of the pietà is heightened in a tight, close-up view in a Belgian book of hours, c. 1480–1490, illuminated by the Master of Antoine Rolin (Fig. 24). [58] The image serves as a frontispiece for the *Stabat mater,* a Marian hymn composed in the late thirteenth century likely by a Franciscan author. [59] Originally part of the liturgies for Lent and Passion week, the text enjoyed a widespread popularity in the devotional lives of lay people. In this case, the hymn continues over four pages, beginning with a moving description of the Virgin Mary: "The grieving Mother

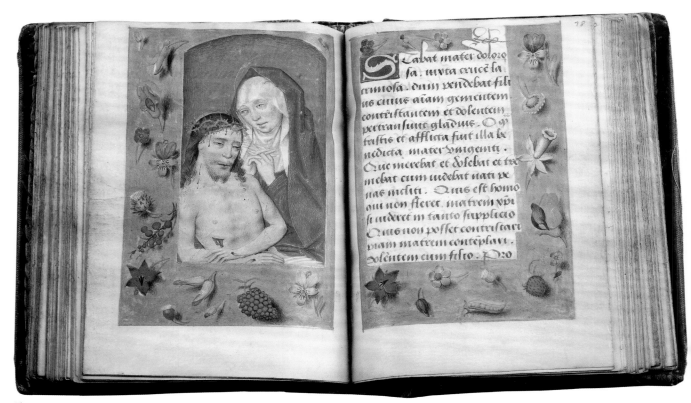

Fig. 24

stood beside the cross weeping where her Son was hanging. Through her weeping soul, saddened and grieving, a sword passed. O how sad and afflicted was that blessed mother of the Only-begotten! Who mourned and grieved and trembled with seeing the torment of her glorious Son."[60] Then, two questions challenge the reader: "Who is the man who would not weep seeing the Mother of Christ in such agony? Who would not be sorrowful on beholding the pious mother suffering with her son?"[61] As it continues, the text becomes a prayer addressed to the Virgin as a surrogate of suffering: "O Mother, fountain of love, make me feel the power of sorrow, that I may grieve with you."[62] The speaker begs "to stand beside the cross" and "to be gladly joined" with the Virgin "in mourning"; and near the end, a verse declares: "Let me be wounded with gashes, inebriated in this way by the cross on account of the love of your Son."[63]

This desire to be "inebriated" (*inebriari*)—quite literally made intoxicated and delirious—by the Passion is given a visual focus in the miniature opposite the hymn's opening verses. Instead of supporting Christ's body, the Virgin clasps her hands in prayer, becoming a model of both grief and devotional reverence. Propped on Mary's lap and against the corner of a window-like opening, Jesus is a ghastly sight, his wounds still bleeding but his lips and cheeks turning a grayish blue. Yet the surrounding page is accented with a golden background decorated with orchids, violets, and other flowers, along with a bunch of grapes; and on the opposite folio are more flowers, a bursting peapod, and a ripe strawberry. Beyond the overt Eucharistic symbolism of grapes, these details frame the bleeding and bruised body as a source of multi-sensory intoxication, an invitation not only to see but to touch, smell, and taste the Passion.[64]

Fig. 24. Master of Antoine Rolin, *Pietà*, c. 1480–1490, tempera and gold on vellum, each page 4½ × 3⁹⁄₁₆ in. (11.5 × 9 cm), fols. 77v and 78r. Acquired by Henry Walters, W.431. The Walters Art Museum, Baltimore, Maryland.

Fig. 25. Unidentified artist (Germany), *Mary as Mother of Sorrows*, c. 1440–1450, colored woodcut, image 10⅝ × 7½ in. (27 × 19.1 cm), 10666 D. Staatliche Graphische Sammlung, Munich, Germany.

Fig. 25

Mother of Sorrows: Learning to Weep

The Virgin Mary's sorrows began long before the events of the Passion. In a hand-colored German woodcut, c. 1440–1450, Mary's pain is linked not only to the Crucifixion but also to earlier moments in the life of Christ (Fig. 25).[65] During the fourteenth and fifteenth centuries, especially in northern Europe, these moments were organized into sets of sorrows, typically five or seven, of the Virgin.[66] The print preserves the earliest tradition of five sorrows, represented by scenes from Christ's childhood and his final days: the Presentation, the loss of the Christ Child in the temple, the Arrest of Jesus, the Crucifixion, and the Entombment. The Presentation, depicted on the upper left, was included in most enumerations of the sorrows because it was the moment of Simeon's prophecy of Jesus's fate, as well as that of his mother. According to the Gospel of Luke, the priest says to Mary: "Behold this child is set for the fall, and for the resurrection of many in Israel … And thy own soul a sword shall pierce, that, out of many hearts, thoughts may be revealed" (2:34–35). In the woodcut's center, the prophecy's violent metaphor is made real in the form of a sword piercing Mary's chest, a blunt motif that makes explicit Mary's suffering as both a mental and physical trauma.

Based on the Stötteritz Master's training and stylistic influences, the most obvious models for the Cummer *Mother of Sorrows* are Netherlandish works, specifically the paintings produced by Dirk Bouts and his workshop in Louvain. Bouts seems to have specialized in images of the sorrowful Mary, though usually in combination with a depiction of Christ, as in the *Mater Dolorosa* and *Christ Crowned with Thorns*, c. 1470–1475, now in London's National Gallery (Fig. 26).[67] Known through several,

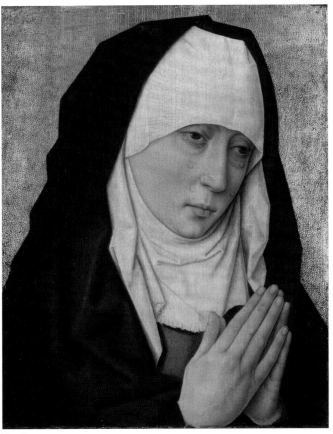 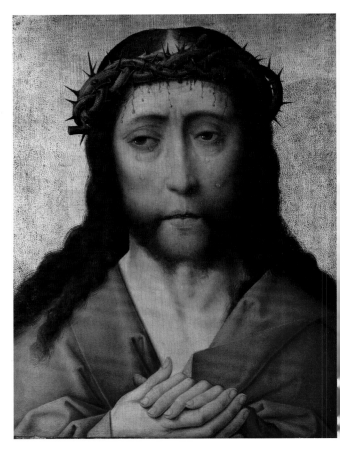

Fig. 26

almost identical, copies, this particular Mother of Sorrows is considered the only version dating to the artist's lifetime. As in the Cummer panel, Bouts employs a bust-length format and gold background to focus attention on the Virgin's subdued emotions. The figure's presence is also heightened by the realistic details of the face, tears, hands, and clothing. In this case, the Virgin was clearly designed as a pendant to the image of the suffering Jesus, who is dressed in a red cloak and crown of thorns typical of scenes of his mocking and the *Ecce Homo*, when Jesus is presented to the crowd by Pontius Pilate. But in most related paired paintings, Netherlandish or otherwise, Mary is joined by the Man of Sorrows, a non-narrative devotional theme in which Christ displays the wounds of the Crucifixion.[68]

In a rare German example, contemporaneous with the Cummer panel and also by an anonymous Nuremberg artist (the Master of the Dinkelsbühler Kalvarienberges), Mary is paired with an unusual Christ figure, one who combines the characteristics of the Man of Sorrows with the Jesus of the *Ecce Homo* wearing his cloak and thorny crown (Fig. 27).[69] The two panels survive today as a diptych; but since the hinged, box-like frame is of modern manufacture, we cannot be sure of their original con-

Fig. 26. Workshop of Dirk Bouts, *Mater Dolorosa* and *Christ Crowned with Thorns*, c. 1470–1475, oil on oak panel, 14½ × 11 in. (36.8 × 27.9 cm) and 14½ × 10¹⁵⁄₁₆ in. (36.8 × 27.8 cm), NG 711 and NG 712. © National Gallery, London / Art Resource, NY.

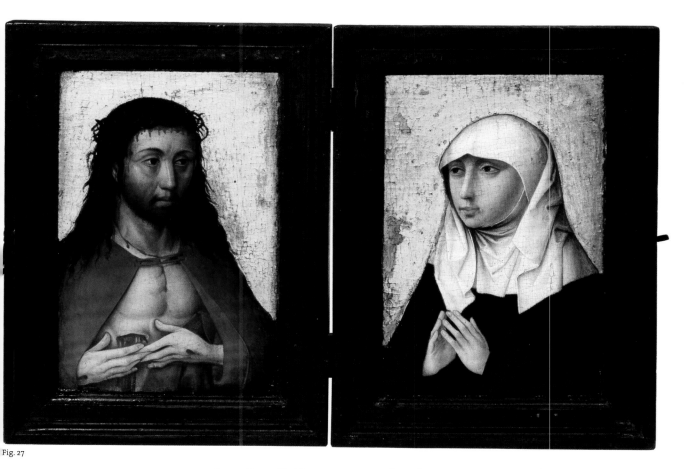

Fig. 27

Fig. 27. Master of the Dinkelsbühler Kalvarienberges, *Diptych with Christ as Man of Sorrows and Virgin Mary*, c. 1470, tempera on wood, each panel 8¼ × 5½ in (21 × 14 cm), Inv. Nr. MSA 12576. Stiftsmusuem, Museen der Stadt Aschaffenburg, Aschaffenburg, Germany. Photograph courtesy of Ines Otschik.

figuration. (Evidence suggests that the Bouts paintings of this type were simply hung side by side.[70]) Yet the unusually small scale of the panels certainly argues for the possibility that they have always been linked in this way in order to facilitate their portability and use in private devotion. In any case, the diptych's Virgin Mary is a simplified and less realistic version of the Bouts Mother of Sorrows, shown in three-quarter view, her head and neck covered, and her hands lightly pressed together in prayer. However, her expression is more sweet than sad; and she sheds no tears as she looks at her son, even though blood trickles from his head and gushes from his side wound.

Although inspired by the style of Netherlandish art, the Stötteritz Master's conception of the Mother of Sorrows is more similar to a painting of the subject attributed to the workshop of Simon Marmion and now in Bruges (Fig. 28).[71] Marmion was a well-known French painter and manuscript illuminator, who worked off and on for the dukes of Burgundy, Philip the Good and Charles the Bold.[72] In the Bruges panels, Mary's bowed head and streaming tears are matched by those of the Man of Sorrows, a figure clearly existing somewhere between life and death: upright with

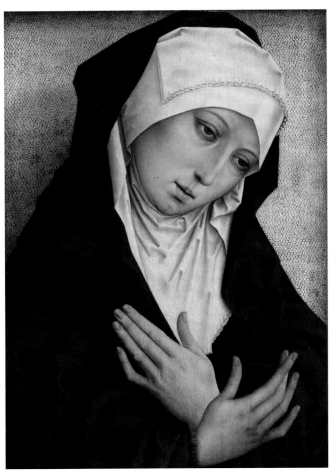 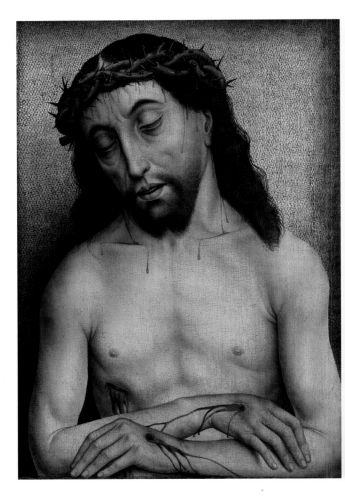

Fig. 28

his wounds still bleeding but with grayish blue lips and closed eyes (compare to the *Pietà* by a follower of Marmion in Fig. 24). Pressed forward by the shallow space, the figures' bodies are made especially real due to the shadows they cast against the backgrounds and by the placement of Jesus's arms along the panel's lower edge, a device not unlike the window-sill of the Cummer panel. But the most noticeable links to the Cummer *Mother of Sorrows* are the active hands of Mary, one pressed against her mantle and the other gesturing toward Christ. In place of the typical static gesture of prayer, these hands suggest movement and the nervous energy of thought.

From their overall composition to their details, the Bruges panels—like all of these paired paintings with their hieratic postures and gold backgrounds—reveal their indebtedness to the Byzantine models that inspired them. Indeed, by the fifteenth century, many icons from Crete and elsewhere had made their way to northern Europe, where their style and subjects were quickly assimilated.[73] The expressive hands of the Bruges Mary are obviously borrowed from a Mother of Sorrows similar

Fig. 28. Workshop of Simon Marmion, *Mater Dolorosa* and *Christ as Man of Sorrows*, c. 1480, oil on panel, each 17⁵⁄₁₆ × 12 in. (44 × 30.5 cm), Inv. 0.201-202. © Lukas-Art in Flanders vzw. Musea Brugge, Groeningemuseum, Bruges, Belgium. Photograph courtesy of Hugo Maertens.

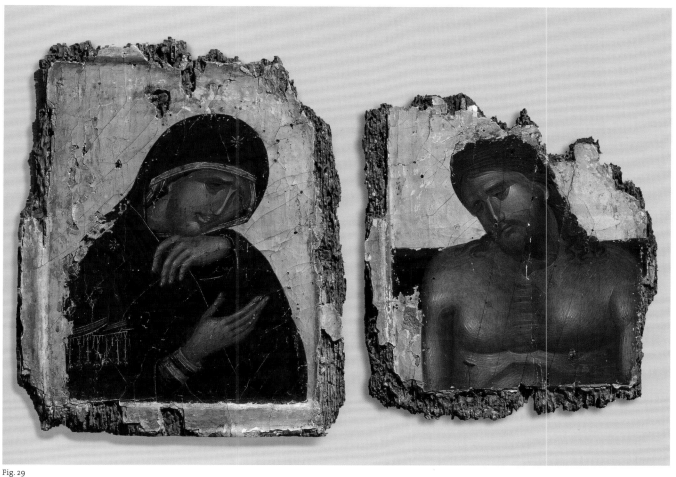

Fig. 29

*Fig. 29. Diptych of the Sorrowful
Virgin and the Man of Sorrows*, late
fourteenth century, tempera on
panel, 10⅝ × 8¼ in. (27 × 21 cm) and
8¹¹⁄₁₆ × 7½ in. (22 × 19 cm). Monastery
of the Transfiguration, Meteora,
Greece. Photograph courtesy of
Gaby Frank-Voutsas and Velissarios
Voutsas.

to a fragmentary late fourteenth-century example preserved in a monastery in
Meteora, Greece (Fig. 29).[74] Although less naturalistic than its French imitator, the
icon's Mary is, surprisingly, much more emotionally intense. With her hunched
shoulders, encircling hands, and furrowed brow, she seems to form a perfect knot of
pain. Based on an inscription found on its reverse, this image was used during the
liturgy for Holy Week, displayed on the *epitaphios*, a textile embroidered with a
depiction of the Lamentation or dead Christ.[75] The icon's emphasis on the hands may
specifically reference sermons and other texts, like a ninth-century Good Friday
homily attributed to George of Nicomedia: "I kiss your mother's hands, for she
guided us all ... Alone she saw to birth as now she has seen to burial. She took and
held the precious child and prepared the undefiled body for the grave."[76] Thus
Mary's hands are interpreted as energetic agents of her maternal care for her son—
at his birth and his burial—as well as symbolic signposts guiding the believer.

In the European versions of the paired icons, the Man of Sorrows is meant to be the
main focus of attention. In fact, there are more surviving panels of this theme than

38

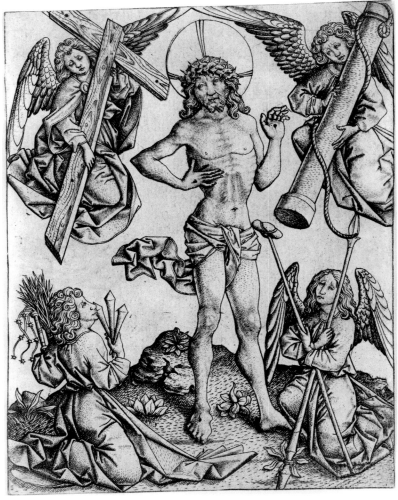

Fig. 30

of the Mother of Sorrows, suggesting its popularity as an autonomous subject.[77] Yet, even in images in which the Man of Sorrows is central, he is often joined by figures that help shape a response. In an engraving of the Man of Sorrows by the Master E. S., Jesus looks directly out at the viewer while four angels display Instruments of the Passion, along with expressions of grief (Fig. 30).[78] Of course, human surrogates are the best way to model an emotional response. In Martin Schongauer's engraving *Man of Sorrows between Mary and John*, Jesus is flanked by his mother and his youngest and most beloved apostle (Fig. 31).[79] As in the Cummer *Mother of Sorrows*, the print employs a window opening as a frame; and in both painting and print, Mary's body and clothing press up against one corner and overlap the narrow foreground ledge. As John and Mary gently support Christ's body with their hands, their emotional experience combines seeing, crying, and touching. The Virgin's pose, with one hand on Jesus's wounded torso and the other wiping her tears, is yet another link to the Stötteritz Master in its echo of the weeping figure standing behind Mary in the Leipzig-Stötteritz triptych (Fig. 8).

Although not as familiar, the Mother of Sorrows could also function as an independent subject, especially in the tradition of Byzantine painting. The Cathedral of Saint Vitus in Prague preserves one such example, an unusual painting on paper that has been collaged onto a gilded wood panel (Fig. 32).[80] This image copies a

Fig. 30. Master E. S., *Christ as the Man of Sorrows Surrounded by Four Angels Carrying Instruments of the Passion*, c. 1450–1460, engraving, image and sheet 5 15/16 × 4 1/2 in. (15.1 × 11.5 cm). George Nixon Black Fund, 34.602. Museum of Fine Arts, Boston, Massachusetts.

Fig. 31. Martin Schongauer, *Man of Sorrows between Mary and John*, c. 1470–1475, engraving on paper shaped to the arched top, second state, image and sheet 7 5/8 × 5 1/2 in. (19.4 × 14 cm). Gift of George W. Davison (B.A. Wesleyan 1892), 1952, DAC 1952.D1.8. Open Access Image from the Davison Art Center, Wesleyan University, Middletown, Connecticut. Photograph courtesy of R.J. Phil.

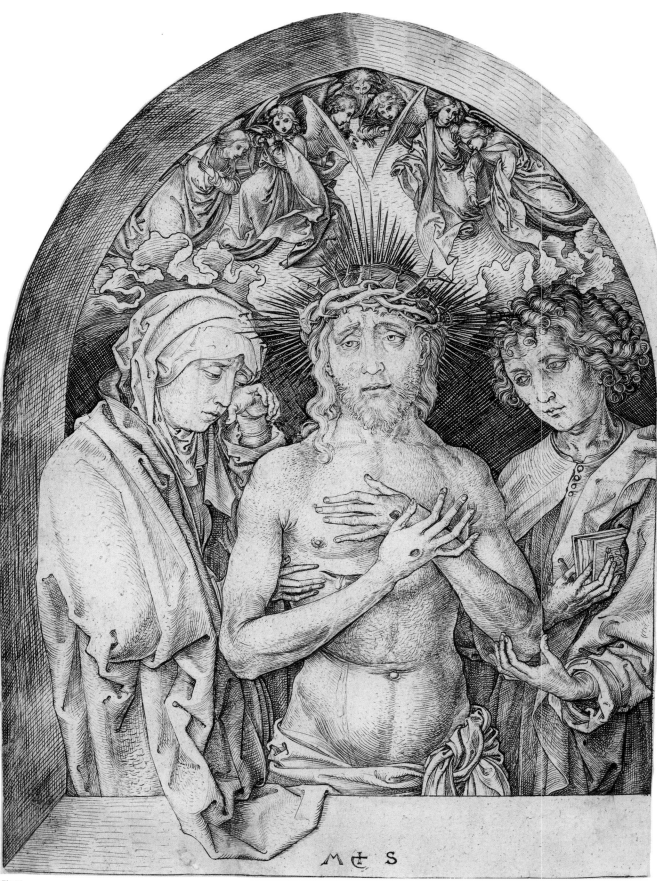

Fig. 31

Fig. 32

famous icon of the sorrowful Mary housed in the Franciscan church of Santa Maria in Aracoeli on the Capitoline Hill in Rome.[81] The icon's initial fame depended on the belief that it was created by the apostle Luke, who, according to tradition, painted three images of the Virgin. In two of these, she appears with the Christ Child; but in the third, she is alone.[82] Beginning in the mid-thirteenth century, the Roman icon became the center of an increasingly popular and competitive communal cult. And by the mid-fifteenth century, it was celebrated by a confraternity to which most of the city's citizens belonged. Its devotional and civic importance was clear when it was carried through the streets in the grand annual procession on the night preceding the feast of the Assumption. Like the Cummer panel, the icon depicts Mary beneath the cross gesturing with both hands. Although no tears are depicted, her sorrow is implied by the drops of blood streaking her face and blue mantle. Further, viewers apparently interpreted the figure as weeping; in a 1375 guidebook to Rome, the author describes the image as painted "with tears in her eyes."[83]

In 1440, bishop Nicodemus Della Scala donated a similar Lukan icon of Mary to the cathedral in Freising, where it was enshrined in an elaborate altarpiece (Fig. 33).[84] The icon's image of Mary is the result of several restorations, the last probably in the fourteenth century. The degree to which it was treasured is made clear by the gilded metal and enamel revetment commissioned by Manuel Dishypatos, the metropolitan of Thessalonike around 1258, well before it ended up in Germany. The frame includes a Greek inscription that clarifies the icon's meaning and function: "Kindly accept this offering, O Virgin, and by your intercession grant that we may pass though this transitory life without suffering."[85] Gesturing toward an unseen Christ, as well as toward the icon's beholder, Mary's hands make clear her role as advocate for mankind, a channel through which prayers are relayed to God.

Fig. 32. Unidentified artist (Bohemia), *Ara Coeli Madonna*, c. 1355, tempera on paper on punched and gilded panel, 11⅜× 8⅝ in. (29 × 22 cm), HS 3422a,b (K98). Metropolitní Kapitula u Sv. Víta, Prague, Czech Republic.

Fig. 33. Unidentified artist (Byzantine), *Icon of the Virgin (Lukasbild)*, mid-thirteenth to fourteenth century, tempera on panel with gilt revetment, image 7¹¹⁄₁₆ × 5¼ in. (19.5 × 13.4 cm), F1. Treasury of Freising Cathedral, Freising, Germany.

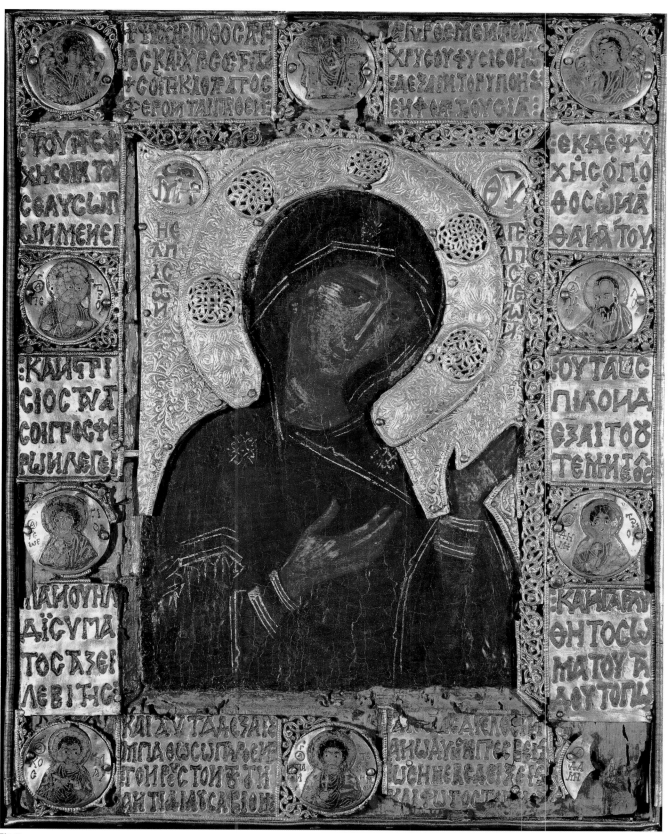

Fig. 33

This same role is also articulated through the gestures in the Cummer painting, where the figure acknowledges the beholder with her open palm yet also signals Christ's presence through the direction of her stare and the lifting of her veil (Fig. 1). These gestures, along with the bust-length format and gold background, are definitely based on a Byzantine model like the Freising icon. As in the paintings of the Mother of Sorrows by Bouts and Marmion, the Stötteritz Master has created his own Westernized version of an icon, one that updates the Lukan tradition of the lone Mary through a more naturalistic style and even a clarification of setting and narrative. Instead of looking outward, Mary's gaze makes clear her location beneath the cross; and in place of formalized gestures and dry eyes, her hands become busy and accessibly human and her swollen eyes weep crystalline tears. For the painting's fifteenth-century audience, the connection to the Lukan icon may have been much more obvious than for modern viewers and much more significant.[86] Its links to such images were not just about artistic emulation. In the tradition of medieval copies, the *Mother of Sorrows* was invested with the aura of the distant original. As such, it retained the efficacy of the Lukan prototype, not only as an intercessory agent, but also in terms of miraculous powers to heal, protect, and transform.

Derived from the figure of Mary standing beneath the cross, but removed from the specifics of the biblical scene and the explicit presence of Christ, the Cummer *Mother of Sorrows* is a close-up of pure response. The Virgin Mary becomes a surrogate for the viewer, a way of vicariously experiencing the Passion of Christ by sharing in her compassionate suffering.[87] This is the specific goal stated by devotional texts, such as the *Stabat mater*: "O Mother ... make me feel the power of sorrow, that I may grieve with you." In a recent study of similar texts, Sarah McNamer seeks to expose the "cultural mechanism" responsible for the "production of compassion."[88] Her approach follows that of Catherine Lutz, who in her book *Unnatural Emotions* insists that emotional experience is "not precultural, but pre*eminently* cultural."[89] In its cultural context, empathy is carefully framed and structured as a practice or performance, one that relies on and is prompted by devotional "scripts" and images. In a variety of texts on the Passion (whether in Latin or the vernacular), the reader is instructed to produce an imaginative recreation of events, primarily through the experience of the Virgin Mary.[90] Thus, according to McNamer, these texts ultimately "feminize" the reader, who "learns to perform the events of the Passion like a mother."[91] The act of weeping is central to this performance, as a kind of art that can be learned and perfected. McNamer cites an anonymous tract entitled *The Art of Weeping (De arte lacrimandi)* in which the Passion is narrated by Mary, who repeatedly instructs the reader: "Come learn to weep from me."[92] Of course, this notion of feminizing the devotee, whether male or female, lays bare the point of empathy: to enable us to see the world through anyone's eyes, including someone completely unlike us in body and experience. In the Middle Ages, tears were not

exclusively male or female but carefully classified in a hierarchy of value. The Virgin's tears were "tears of compassion" (*lacrimae compassionis*) and, like all tears, were considered a precious gift from the Lord and to the Lord.[93]

Empathy in Detail

In the case of the Cummer *Mother of Sorrows*, empathy is about much more than tears (Fig. 1). Through its meticulously painted details, the image is designed to inspire a multi-sensory response, one that thoroughly implicates the viewer and his or her body. On one level, the realistic details blur the boundary between the space of the painted Virgin and the actual space of the beholder. Indeed, this liminality is specifically articulated by the window-sill along the panel's lower edge. This illusionistic device serves as a sort of shallow stage on which the Virgin's clothing, hair, and hands are presented, as they gather, spill over, and threaten to gesture through the picture plane. However, the miniature scale of the painting partly reverses the window effect, that is, the sense that the painting is contiguous with our world. The figure's small size requires a mental and physical adjustment; instead of standing back and letting the picture merge with our surroundings, we must enter into the painting's space and linger there, becoming part of its reality.[94]

Of course, on a purely aesthetic level, the vivid details are meant as demonstrations of the artist's virtuosity, especially the white veil pulled down over Mary's brow, with its central crease, cascading folds, and one end gripped in her hand (Fig. 34). As in other fifteenth-century northern paintings, the successful rendering of clothing and textiles of various sorts was a key element in the production of a convincing three-dimensionality, as exploited with such finesse in the prints of Schongauer (Figs. 20, 31, and 36–38). The Stötteritz Master, like other artists of the period, practiced these illusionistic skills through drawings that isolated draped fabrics and perfected the play of light and shadow on every fold.[95] Besides their necessity as subject matter, textiles were essential to the visual simulation of the material world. As such, their depiction suggested more than just form, but also texture, weight, warmth, and movement.

From scenes of the Crucifixion to the pietà (Figs. 18 and 22), the Virgin's veil often plays a meaningful role. Gathered in her hand, the cloth becomes an extension of her body and a vehicle for the act of touching. Furthermore, even a modest piece of fabric could garner a status well beyond simple clothing, as seen in a German woodcut depicting three famous relic collections (Fig. 35).[96] Produced around 1470, the print includes images of relics from Maastricht, Aachen, and Kornelimünster, each explained in a caption. Except for two head and arm reliquaries and a few liturgical objects, these collections consisted primarily of textiles. Starting on the

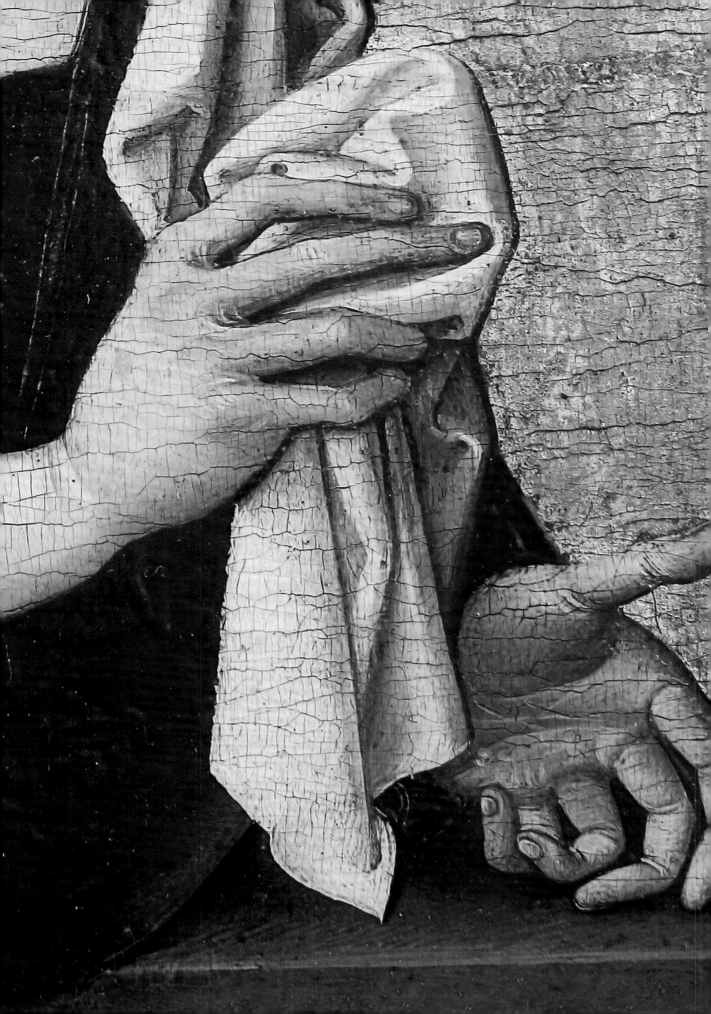

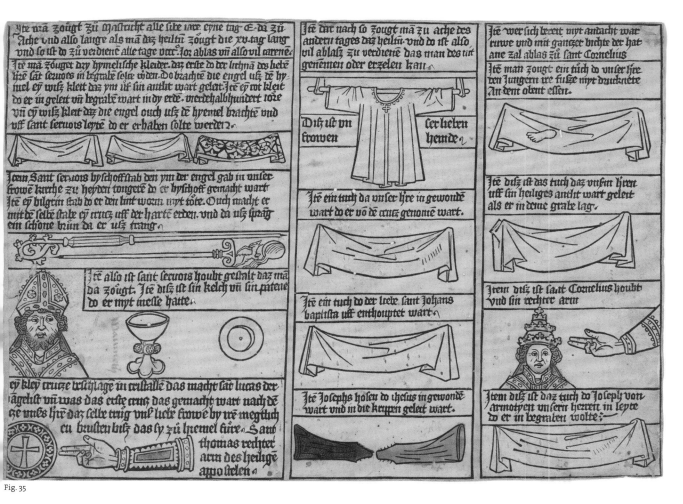

Fig. 35

Fig. 34. See Fig. 1 (detail).

Fig. 35. Unidentified artist (Germany), *The Holy Relics from Maastricht, Aachen, and Kornelimünster*, 1468 or 1475, colored woodcut, 10¹³⁄₁₆ × 14¾ in. (27.5 × 37.5 cm), 118308 D. Staatliche Graphische Sammlung, Munich, Germany.

left, the woodcut depicts three fabrics believed to have been delivered by angels as clothing for Saint Servatius. The three textiles on the right are all linked to Jesus: the towel with which he washed the Apostles' feet, appropriately marked with a footprint; the cloth that covered his face in the tomb; and the burial shroud provided by Joseph of Arimathea and stained with blood. In the print's middle are the "great relics" of Aachen. Two are also associated with Christ: the loincloth sprinkled with blood, in the center; and his swaddling clothes, consisting of Joseph's leggings or hose, which, according to one tradition, were all that was available at the time. Directly above the hose is the blood-stained cloth that once held the decapitated head of John the Baptist. But taking pride of place, at the top middle, is the tunic or under-shirt of the Virgin Mary, a relic that was guaranteed to attract pilgrims from throughout Europe every seven years when the Aachen collection was put on display.[97]

There were many relics of the Virgin's clothing in the Middle Ages. As early as the fifth century, relics of her robe and veil were celebrated in Constantinople.[98] And after the city's conquest in 1204 by Crusaders, innumerable relics of her tunic, cloak, belt, and veil ended up in collections in the West.[99] Since there were no bodily remains of the Virgin (due to the Assumption), these pieces of her clothing were especially treasured. Not only had they been in physical contact with her but perhaps even with her son, whether during his infancy or final days. Indeed, some Marian textile relics were believed to be stained with her breast milk and others with Christ's blood. Like these various relics, the veil in the Cummer *Mother of*

Fig. 34

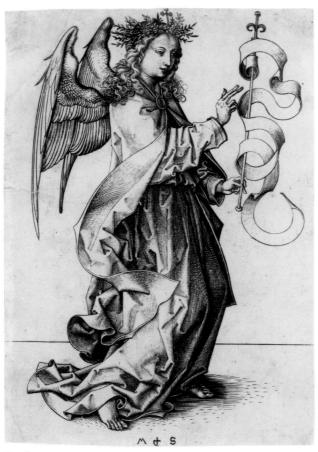

Fig. 36

Fig. 37

Sorrows is represented as a link to both the Virgin's body and to Christ's body (Fig. 1). Mary's manipulation of the veil is ambiguous, implying movement toward her eyes, as well as beyond the frame. Suspended in between, the pristine fabric will soon either be soaked with tears or stained with blood, or both. As in the *Ara Coeli Madonna* in Prague (Fig. 32), and other late medieval Passion images, the Virgin's clothing is sometimes depicted covered with blood drops. In a painting of the Crucifixion, attributed to the workshop of Rogier van der Weyden and now in Berlin, Mary kneels and embraces the cross, allowing the blood to rain down on her veiled head and face, mixing with her tears.[100]

Of course, the veil in the Cummer panel also serves as a covering for the Virgin's hair, and as such, a customary sign of modesty and purity. Yet, the Virgin's hair is still quite noticeable, falling in luxurious, auburn waves over her right shoulder, arm, and chest (Fig. 1). These beautiful, sensuous locks are more typical in images of the Virgin Mary as a young woman. In paired engravings of the angel Gabriel and the Virgin Annunciate, for instance, Schongauer takes special delight in the coiffure of both the angel and Mary (Figs. 36 and 37).[101] As indicated by the potted lilies and the book of Scripture, Mary is presented as the embodiment of purity; and her long hair is a sign of her virtue.[102] And the veil, although ostensibly meant to conceal, joins the hair as one flowing unit. Held on her head by a slender diadem, the cloth encircles Mary's body, wrapping around her shoulder and sweeping behind her, its lower edge pointing up to the abundant hair falling down her back. In *The Little Nativity*, another engraving by Schongauer, the Virgin's hair is but one of

Fig. 36. Martin Schongauer, *The Archangel Gabriel*, c. 1485–1490, engraving, image 6⅝ × 4⅝ in. (16.8 × 11.8 cm), 10988 D. Staatliche Graphische Sammlung, Munich, Germany.

Fig. 37. Martin Schongauer, *The Virgin of the Annunciation*, c. 1485–1490, engraving, image 6¾ × 4¹¹⁄₁₆ in. (17.1 × 11.9 cm), 11005 D. Staatliche Graphische Sammlung, Munich, Germany.

Fig. 38

Fig. 38. Martin Schongauer, *The Little Nativity*, c. 1480–1490, engraving, image 6¼ × 6⅛ in. (15.8 × 15.6 cm), 67333 D. Staatliche Graphische Sammlung, Munich, Germany.

Fig. 39

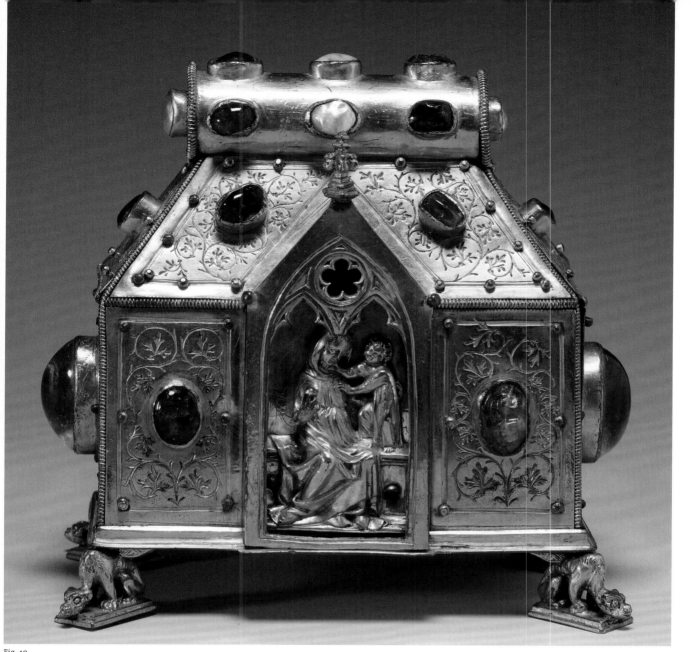

Fig. 40

many contrasting textures, from wood and stone to hay and fabric (Fig. 38).[103]
Kneeling in adoration of the Christ Child, Mary crosses her arms over her chest and,
in the process, seems to gently stroke her hair. Like the Stötteritz Master, Schongauer
depicts the Virgin's hair as long and wavy, with individual strands curling up at the
ends. According to the Church, Mary's virginity was perpetual and thus the perfec-
tion of her appearance, including her hair, is featured often in images of the Passion
and even in scenes of her death.[104]

Shimmering with golden highlights (accomplished with touches of yellow), the
Virgin's hair in the Cummer painting is impossible to overlook (Fig. 39). On the
lower left, several curling strands catch the light and even appear to fall over the
gray ledge into our space. This is a bravura display of technique, since each strand is
the result of a single, confident brushstroke. As with the depiction of the veil, the
aim here is to prompt a multi-sensory response, one that conflates seeing with a
desire to touch, along with the impression of latent movement. These glinting
strands are but weightless wisps sure to change position as we gaze at them, react-
ing to our slightest breath.

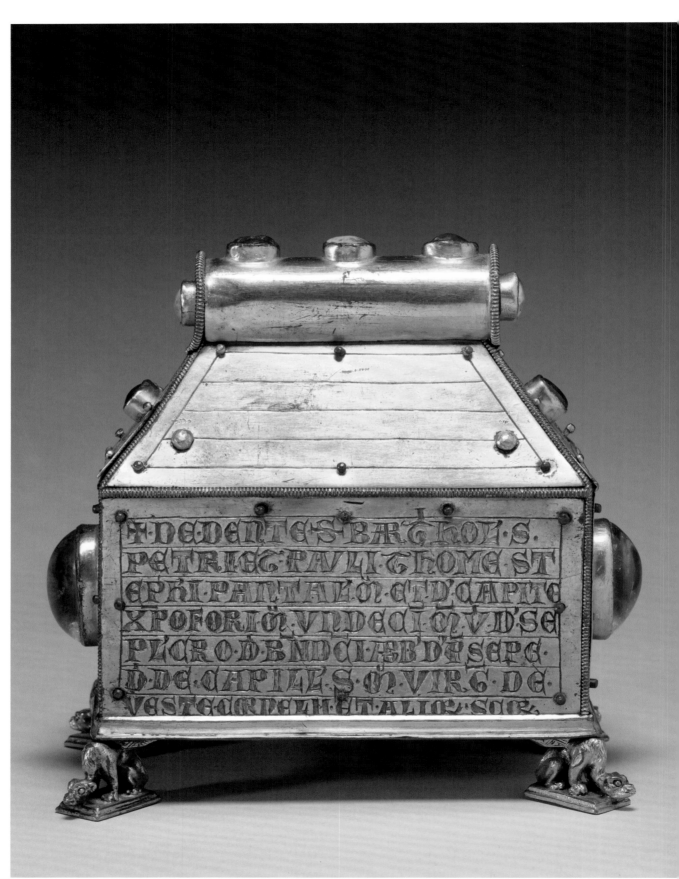

Fig. 41

Fig. 41. Reverse, Fig. 40.

For the panel's original audience, hair was invested with notions of memory and love, both familial and romantic. Locks of hair were preserved as love tokens and as mementos of the dead, sometimes carried as talismans or crafted into objects or sewn into clothing.[105] Further, as with the Virgin's veil, her hair took on a literal reality in the form of relics.[106] Since most relics were not much to look at, they required the mediation of reliquaries often made of precious materials. A late thirteenth- or early fourteenth-century German example is constructed of gilded copper panels studded with mother-of-pearl, rubies, turquoise, and other gem stones (Fig. 40).[107] Known as a *bursa*, because of its purse shape, the reliquary also suggests a small building, complete with a Gothic arch framing a golden relief of the Madonna and Child. On the reverse, an engraved inscription in Latin lists the contents once held in the wooden core (Fig. 41).[108] The list is dominated by the remains of saints, beginning with the "tooth of Saint Bartholomew," along with relics of Peter, Paul, Thomas, Stephen, Pantaleon, Christopher, Benedict Abbot, Cornelius, and various martyrs. The contents also included two relics of Jesus: the "sepulcher of the Lord" (*sepulcro Domini*) and the "cradle of the Lord" (*praesepe Domini*); and finally, as listed on the penultimate line, there was one relic of his mother: the "hair of the blessed Virgin Mary" (*capillis santae Mariae Virginis*).

As stressed in recent scholarship and exhibitions, the gathering of disparate relics in a single container was not unusual.[109] This was a way to accumulate the power of the saints in one place, and also, through careful selection, create purposeful connections and meanings. Thus, in this case, the relics of the cradle and the sepulcher allowed a merging of the Nativity and the Passion, a collapsing of time indicative of images of the Madonna and Child that include prefigurations of Jesus's suffering and death. And literally and figuratively linking the cradle and grave were strands of the Virgin's hair, as delicate as the incised vine scrolls surrounding the gemstones on each gilded panel. In this way, the seemingly cheerful relief of Mary and the Christ Child on the front was given a somber undertone by the remains of the tomb within. Although the reliquary is currently empty, we can imagine that the large rock crystal cabochons, like magnifying windows, may have especially attracted devotees eager for a glimpse of the Virgin's golden hair.

Beyond her veil and hair, the Virgin's hands are what make the Cummer *Mother of Sorrows* so unusual (Fig. 34). As revealed by infrared-reflectography, the artist specifically changed the design of the veil and right hand so that Mary's fingers were made more completely visible (Fig. 9). Both hands are realistically depicted with fingernails and the fine creases of skin at each joint and in the open palm. As in the Byzantine icons that inspired the painting (Figs. 29, 32, and 33), the hands are important generators of action and meaning. Not only does Mary weep, but she also grasps her veil in her right hand and gestures with her left in a wonderfully ambiguous choreography that implies a simultaneous inward and outward dynamic. As

52

Fig. 42

Fig. 42. Unidentified artist
(Germany), *The Hand as the Mirror
of Salvation*, 1466, colored woodcut,
image 15⅜× 10⅜₆ in. (39 × 26.5 cm),
178913 D. Staatliche Graphische
Sammlung, Munich, Germany.

noted above, the right hand and veil hover between actions, suggesting both the wiping of Mary's tears and the maternal care for Christ's body; and the left hand opens toward the viewer in a traditional gesture of intercession. Drawing us into the image, as well as beyond its frame, the Virgin's hands are the equivalent of those once gesticulating in front of the panel, pressed together in prayer, manipulating the beads of a rosary, or turning the pages of a book of hours.

Indeed, the Virgin's hands are a link to the active body of the devotee. In the Middle Ages, the hand was treated as stand-in for the body as a whole and as a way of structuring devotional practice in terms of memory and meditation. A German woodcut, dated 1466, depicts the hand as a mnemonic diagram for learning the steps to repentance (Fig. 42).[110] The opening of the Latin inscription below states: "This hand contains a mirror of salvation" (*Hec manus continent speculum humane saluationis*). To the left of the wrist, another text explains the necessity of recognizing evil: "If you know the will of God, recognize evil, so that you may avoid it. If you have done evil, regret it. If you regret it, confess it. When you have confessed it, do penance." According to the text on the right, each digit of the hand represents a different step: "The thumb signifies God's will, the index finger understanding, the middle finger contrition, the ring finger confession, the little finger repentance." These steps are broken down into stages, inscribed on the hand and corresponding to the joints of each finger. The little finger, for instance, represents the steps of penance: "prayer, fasting, alms." Thus the hand is a substitute for the entire person in terms of their search for spiritual and moral perfection.

Woodcut images of both the left and right hands are featured at the beginning of the *Schatzbehalter der wahren Reichtümer des Heils*, or "Treasure Chest of Salvation," a book published in 1491 by Anton Koberger in Nuremberg (Fig. 43).[111] Michael Wolgemut and Wilhelm Pleydenwurff were responsible for the ninety-six full-page images accompanying the German text by the Franciscan Stephan Fridolin. With their thin, somewhat over-articulated fingers, these lifesize hands are clearly related stylistically to those of Mary in the Cummer panel. Also, the book's text brings us closer to the devotional goals prompted by the *Mother of Sorrows*, in that this "treasure chest" contains meditations on the Passion of Christ, with the hands as a kind of table of contents. As Claire Richter Sherman notes: "The hands, as privileged parts of the body linked to the soul, act as metaphors for a bodily shrine, holding, grasping, and perceiving the inner wisdom revealed in the text and images of the book."[112] Here the hands are marked with numbers—one through fifty on the left, and fifty-one through one hundred on the right—each corresponding to a separate meditation. Within the text, the author acknowledges the difficulty of using such a system and suggests additional ways of grouping meditations—by color, or by constructing more hands out of paper, drawing rings on their fingers, and labeling the rings with various titles. No matter how unwieldy, the desire is to encour-

Fig. 43

age an interactive devotion in which the hands and, potentially, the whole body are engaged as instruments of piety.

Near the end of the *Schatzbehalter*, another pair of lifesize hands appear, although they are now meatier with thick fingers made to accommodate little images (Fig. 44).[113] It is almost as if the hands at the beginning of the book have become swollen with images. The left hand features busts of the twelve Disciples, each identified through captions and attributes and numbered to correspond to different sections of the Apostles' Creed in the column to the right. All twelve figures turn in reverence toward depictions of the Man of Sorrows and the Virgin Mary on the two joints of the thumb (the powerful, master digit). On the right hand, another set of saintly figures face different images of Christ and Mary, here transformed as king and queen of heaven. As a mnemonic aid, these hands would seem an effective device transferred to the devotee's actual hands, every finger mentally tattooed with images of Mary, Christ, and the saints—a virtual gallery of sacred art. In this way, the notion of embodying images is made literal, as a mental operation of memory and meditation is facilitated by the hands, by the body itself.

Fig. 43. Workshop of Michael Wolgemut and Wilhelm Pleydenwurff, *The Left Hand* and *The Right Hand*, colored woodcuts, each image 9¹⁵⁄₁₆ × 6⅞ in. (25.3 × 17.5 cm), Stephan Fridolin, *Schatzbehalter der wahren Reichtümer des Heils* (Nuremberg: Anton Koberger, 1491), fols. e6v and 7r. Acquired by Henry Walters, 91.1086. The Walters Art Museum, Baltimore, Maryland.

Fig. 44

Fig. 44. Workshop of Michael Wolgemut and Wilhelm Pleydenwurff, *The Left Hand* and *The Right Hand*, colored woodcuts, each image 9⅞ × 6⅞ in. (25.1 × 17.5 cm), Stephan Fridolin, *Schatzbehalter der wahren Reichtümer des Heils* (Nuremberg: Anton Koberger, 1491), fols. v3v and v4r. Acquired by Henry Walters, 91.1086. The Walters Art Museum, Baltimore, Maryland.

While art historians have long been intrigued by the invention of the painted tear—that "shining pearl born of the strongest emotion" (as Erwin Panofsky famously described it), the Cummer *Mother of Sorrows* demonstrates the many ways that artists emotionally engaged their viewers.[114] Indeed, the Stötteritz Master seems to have been well aware of his audience's natural inclination to share the feelings of those in pain, as well as the concomitant need to involve the entire body in the process. Besides the expressive epicenter of Mary's crying face, an empathic response depended on the cumulative effect of the framing details, whether folds in a piece of cloth, stray strands of hair, or the slight bending of the fingers. Thus artistic skill was ultimately in the service of a devotional aim. Through such convincing signs of material and corporeal reality, the artist created a way into the world of the picture and the Virgin's experience. As originally suggested by the German word *Einfühlung*, empathy is a "projection of the self into the object," or, more precisely, a "feeling into."[115] In fifteenth-century devotional practice and the images that fostered it, such an endeavor was not just a mental, affective identification, a sharing of emotion. It was also a sharing of bodies and the fully sensual world in which they live.

Notes

All biblical references in English are from the
Douay-Rheims version.

1 The following description is based on several
 viewings of the video in New York: at the Marian
 Goodman Gallery in August 2010 and at the
 retrospective exhibition of Dijkstra's work at the
 Guggenheim Museum in August 2012. For more on
 the video, see Jennifer Blessing, "What We Still
 Feel: Rineke Dijkstra's Video," in Jennifer Blessing
 and Sandra S. Phillips, *Rineke Dijkstra: A
 Retrospective* (New York, 2012), 29–43 (39–42), figs.
 236–239.

2 Roberta Smith, "A Return to Video Is Moving," *The
 New York Times* (August 13, 2010): C21.

3 Thérèse St-Gelais, "Rineke Dijkstra: A Community
 of Solitudes," *Parachute* 102 (2001): 16–31 (18).

4 Ellen Dissanayake, *Homo Aestheticus: Where Art
 Comes From and Why* (New York, 1992), 142.

5 Lauren Wispé, "History of the Concept of
 Empathy," in *Empathy and its Development*, ed.
 Nancy Eisenberg and Janet Strayer (Cambridge,
 Mass., 1987), 17–37 (17–20); and Dissanayake, *Homo
 Aestheticus*, 142–147.

6 David Brooks, "The Limits of Empathy," *The New
 York Times* (September 30, 2011): A21. The phrase
 "empathy craze" is quoted by Brooks from Steven
 Pinker.

7 Frans de Waal, *The Age of Empathy: Nature's
 Lessons for a Kinder Society* (New York, 2009).

8 On mirror neurons and body mapping, see de
 Waal, *Age of Empathy*, 52–53, 60–61, 79. For the
 work of a scholar working at the intersection of art
 history and neuroscience, see David Freedberg,
 "Empathy, Motion and Emotion," in *Wie sich
 Gefühle Ausdruck verschaffen: Emotionen in Nahsicht*
 (Berlin, 2007), 17–51; and David Freedberg and
 Vittorio Gallese, "Motion, Emotion and Empathy in
 Esthetic Experience," *Trends in Cognitive Sciences*
 11/5 (May 2007): 197–203. See also Kirk Ambrose,
 "Attunement to the Damned of the Conques
 Tympanum," *Gesta* 50/1 (2001): 1–17 (esp. 11–12 and
 sources cited in notes 71–78).

9 Judi Freeman, *Picasso and the Weeping Women: The
 Years of Marie-Thérèse Walter and Dora Maar* (Los
 Angeles, 1994).

10 Ibid., 29. For Spanish Baroque examples of the
 Mother of Sorrows, see Xavier Bray, et al., *The
 Sacred Made Real: Spanish Painting and Sculpture
 1600–1700* (London, 2009), fig. 30 and nos. 21a, 21b,
 and 22.

11 The painting was purchased from the Alexander
 Gallery after it was included in an exhibition
 jointly organized by the Alexander Gallery and
 Colnaghi. See the Colnaghi catalogue: *The
 Northern Renaissance: 15th and 16th Century
 Netherlandish Paintings, an exhibition in association
 with Alexander Gallery New York April 6 to May 14,
 1983* (New York, 1983), no. 23 and pl. 19. The title is
 misleading since the exhibition included several
 German paintings.

12 The photograph was once in the possession of
 Colin Eisler, who examined the painting before its
 sale in 1983. The pre-restoration photograph
 (provided by Eisler) was reproduced in Fedja
 Anzelewsky, "Der Meister des Stötteritzer Altars
 und Wilhelm Pleydenwurff," *Anzeiger des
 Germanischen Nationalmuseums* (1997): 7–30 (fig. 25).

13 The technical analysis was conducted in the
 summer of 2010 by Dr. Narayan Khandekar (senior
 conservation scientist) and Teri Hensick
 (conservator of paintings) at the Straus Center for
 Conservation and Technical Studies, Harvard Art
 Museums, Harvard University. The painting was
 examined using: x-radiography; visible light and
 UV light digital photography; infrared
 reflectography and infrared digital photography;
 x-ray fluorescence spectroscopy (XRF); visible and
 UV reflected light microscopy of paint cross-
 sections and details; scanning electron
 microscopy-energy dispersive spectroscopy (SEM-
 EDS) of paint cross-sections; Fourier transform
 infrared spectroscopy (FTIR) of paint samples; gas
 chromatography-mass spectrometry of the
 binding medium; and polarized light microscopy
 of the wooden support. The full report is on file at
 The Cummer Museum of Art & Gardens.

14 This possible interpretation of the cross-section
 evidence was suggested in a conversation with
 Luuk Hoogstede of the Stichting Restauratie
 Atelier Limburg, Maastricht, The Netherlands.

15 Eisler's attribution is included in the 1983
 catalogue entry (see note 11). In the last three
 decades, the painting has been mentioned only in
 passing in German publications and without
 knowledge of its location beyond an "American
 private collection"; see Anzelewsky, "Der Meister
 des Stötteritzer Altars," 23–24; and Robert Suckale,

Die Erneuerung der Malkunst vor Dürer, 2 vols. (Petersberg, Germany, 2009), 2: 80. (Suckale references Anzelewsky's article and refers to the Cummer painting as a "panel fragment" and associates it with the Stötteritz Master's workshop.) See also the entry in Tanja Jones, et al., *The Cummer Museum of Art & Gardens* (Jacksonville, 2000), 18–19 (no. 6).

16 For the Leipzig-Stötteritz altarpiece, see Anzelewsky, "Der Meister des Stötteritzer Altars"; Suckale, *Die Erneuerung der Malkunst*, 1: 63–75, figs. 68–101, 254, 414, 660–663, and 2: 75–80, figs. 799–805; and Till-Holger Borchert, *Van Eyck to Dürer: The Influence of Early Netherlandish Painting on European Art, 1430–1530* (New York, 2011), 102–103, fig. 108; and 403–405 (no. 220). Note: Anzelewsky's identification of the Master of the Stötteritz Altarpiece as Wilhelm Pleydenwurff is now discredited.

17 Suckale, *Die Erneuerung der Malkunst*, 2: 75.

18 The exterior wings were painted later by another artist with much less skill. On the exterior left wing is Saint John and Saint Paul; and on the exterior right wing is the Stoning of Saint Stephen.

19 Anzelewsky, "Der Meister des Stötteritzer Altars," 23–24.

20 For German drawings of sibyls, not unlike the figure in the Cummer painting and close in date, see *From Schongauer to Holbein: Master Drawings from Basel and Berlin* (Washington, 1999), 27–30 (nos. 2 and 3); and Borchert, *Van Eyck to Dürer*, 290 (no. 126).

21 For the Berlin drawing, see Anzelewsky, "Der Meister des Stötteritzer Altars," 7 and fig. 2; Anzelewsky's entry in *From Schongauer to Holbein*, 67–69 (no. 20); Fritz Koreny, "Aspekte deutscher Zeichnung der Spätgotik: Materialien zur Deutung regionaler Stilmerkmale," in *Aspekte deutscher Zeichenkunst*, ed. Iris Lauterbach and Margaret Stuffmann (Munich, 2006), 11–27 (23–24, fig. 21); Hans Dickel, et al., *Zeichen vor Dürer: Die Zeichnungen des 14. und 15. Jahrhunderts in der Universitätsbibliothek Erlangen* (Petersberg, Germany, 2009), 124–129 (127 and fig. 3); Borchert, *Van Eyck to Dürer*, 403–405 (no. 219); and Suckale, *Die Erneuerung der Malkunst*, 1: 66, 74, fig. 71. Note: Koreny follows Anzelewsky's now discredited attribution of the drawing to Wilhelm

Pleydenwurff. For a sketch of a lone standing figure on the reverse of the Berlin drawing, see *From Schongauer to Holbein*, 67; Anzelewsky, "Der Meister des Stötteritzer Altars," fig. 2; and Suckale, *Die Erneuerung der Malkunst*, 2: fig. 806.

22 For the Budapest drawing, see Anzelewsky, "Der Meister des Stötteritzer Altars," 22–23, fig. 24; Dickel, *Zeichen vor Dürer*, 127–128, fig. 4; and Suckale, *Die Erneuerung der Malkunst*, 1: 75, fig. 103.

23 For the Erlangen drawing, see Koreny, "Aspekte deutscher Zeichnung," 24–25, fig. 24; Dickel, *Zeichen vor Dürer*, 124–129 (no. 44); and Borchert, *Van Eyck to Dürer*, 103, fig. 107.

24 For the definitive work on Hans Pleydenwurff and his circle, see Suckale, *Die Erneuerung der Malkunst*. See also Antje-Fee Köllermann, "Models of Appropriation: The Reception of the Art of Rogier van der Weyden in Germany," in Borchert, *Van Ecyk to Dürer*, 68–81 (77–80).

25 See Borchert, *Van Ecyk to Dürer*, 404; Köllermann, "Models of Appropriation," 77–78, figs. 78–81; and Suckale, *Die Erneuerung der Malkunst*, 1: 159–165, figs. 241–42, 245, 247–250, 252; 2: 95–106 (no. 33), figs. 826–842.

26 See Suckale, *Die Erneuerung der Malkunst*, 1: 77–81, figs. 106, 108–111; and the entry by John Oliver Hand in Borchert, *Van Eyck to Dürer*, 407–408 (no. 222).

27 On the influence of early Netherlandish painting on German art, see Borchert, *Van Ecyk to Dürer*. For the specific sources reflected in the Stötteritz altarpiece, see Borchert, *Van Ecyk to Dürer*, 404.

28 Staatliche Museen, Gemäldegalerie, Berlin. Stephan Kemperdick and Jochen Sander, *The Master of Flémalle and Rogier van der Weyden* (Frankfurt am Main, 2009), 291–296 (no. 23).

29 For the Vienna painting, see Ibid., fig. 89; and Stephan Kemperdick, *Rogier van der Weyden* (Potsdam, Germany, 2007), 46–50, fig. 47.

30 Kemperdick and Sander, *Master of Flémalle and Rogier van der Weyden*, fig. 4; and Felix Thürlemann, "The Paradoxical Rhetoric of Tears: Looking at the Madrid *Descent from the Cross*," in Elina Gertsman, ed., *Crying in the Middle Ages: Tears of History* (London, 2011), 53–75 (56).

31 Borchert, *Van Ecyk to Dürer*, 404.

32 Suckale, *Die Erneuerung der Malkunst*, 1: 458, fig. 730; and 2: 77.

33 Ibid., 1: 458, fig. 731; and 2: 77.

34 Dickel, *Zeichen vor Dürer*, 124–129 (no. 44).

35 Borchert, *Van Ecyk to Dürer*, 404.

36 Stephan Kemperdick, *Martin Schongauer: Eine Monographie* (Petersberg, Germany, 2004), 227–234; Suckale, *Die Erneuerung der Malkunst*, 1: 215–232; and Köllermann, "Models of Appropriation," 77.

37 Kemperdick, *Martin Schongauer*, 239–240.

38 Messling, "Drawing in Germany: From Van Eyck to Dürer," in Borchert, *Van Eyck to Dürer*, 94–103 (103).

39 Entry by Kemperdick in Borchert, *Van Ecyk to Dürer*, 404.

40 On the *Schatzbehalter*, see Richard Bellm, *Der Schatzbehalter: Ein Andachts- und Erbauungsbuch aus dem Jahre 1491*, 2 vols. (Wiesbaden, 1962).

41 Wilhelm Schreiber, *Handbuch der Holz- und Metallschnitte des XV.Jahrhunderts*, 8 vols. (Leipzig, 1926–1930), no. 2334a. There are other surviving impressions in Dresden and Königsberg. For the Master of the Aachen Madonna, see Schreiber, *Handbuch*, 7: 77–78. For a call to reevaluate the work of this master, see the entry by Peter Schmidt in Peter Parshall and Rainer Schoch with David S. Areford, Richard S. Field, and Peter Schmidt, *Origins of European Printmaking: Fifteenth-Century Woodcuts and Their Public* (Washington, 2005), 179–180 (no. 46). Although usually localized to the Upper Rhine, Schmidt argues that many of the figures are based on models in Bavarian painting and thus were probably made in southern Germany; see the entry by Peter Schmidt in Parshall and Schoch, *Origins of European Printmaking*, 232–234 (no. 67). On metalcuts with backgrounds removed, see the entry by Peter Schmidt in Parshall and Schoch, *Origins of European Printmaking*, 86–87 (no. 10).

42 For transcriptions, see Schreiber, *Handbuch*, no. 2333.

43 Gertrud Schiller, *Iconography of Christian Art*, trans. Janet Seligman, 2 vols. (Greenwich, Conn., 1971–1972), 2: 13.

44 On Dismas and Gesmas, the Good Thief and Bad Thief, respectively, and the tradition of showing their souls plucked from their bodies, see Ibid., 2: 13, 116. See also Mitchell B. Merback, *The Thief, the Cross and the Wheel: Pain and the Spectacle of Punishment in Medieval and Renaissance Europe* (Chicago, 1998), esp. 218–265.

45 "Imparibus meritis tria pendent corpora ramis, Dismas et Gesmas in media divina ita potestas, Dismas salvatur, Gesmas vero dampnificatur." For the transcription, see Schreiber, *Handbuch*, no. 2333.

46 Henry Charles Lea, *Materials Toward a History of Witchcraft*, ed. Arthur C. Howland, 3 vols. (Philadelphia, 1939), 3: 515. On the medieval (and later) use of images of the Passion to comfort those about to be executed, see David Freedberg, *The Power of Images: Studies in the History and Theory of Response* (Chicago, 1989), 5–9.

47 Schiller, *Iconography of Christian Art*, 2: 105, 131. Since the scorpion is joined by the sign for Venus (in the form of a brand on the horse on the lower right), there may also be some astrological meanings communicated by the print.

48 For a transcription, see Schreiber, *Handbuch*, no. 2333. On the authorship, see Miri Rubin, *Corpus Christi: The Eucharist in Late Medieval Culture* (Cambridge, 1991), 156. See also Joseph A. Jungmann, *The Mass of the Roman Rite: Its Origins and Development*, 2 vols. (Westminster, Maryland, 1992), 2: 214–216; and Edouard Dumoutet, *Le Christ selon la chair et la vie liturgique au moyen-âge* (Paris, 1932), 169–170.

49 "Ave verum Corpus natum / De Maria Virgine: / Vere passum, immolatum / In cruce pro homine: / Cuius latus perforatum / Unda fluxit et sanguine: / Esto nobis praegustatum / Mortis in examine." For the Latin text and translation, see Christopher Howse, ed., *The Best Spiritual Reading Ever* (New York, 2002), 164.

50 "O dulcis o pie o Jesu Christi, fili Mariae, miserere micht qui passus es pro me. Amen."

51 See the classic study, Otto G. von Simson, "*Compassio* and *Co-Redemptio* in Roger van der Weyden's *Descent from the Cross*," *The Art Bulletin* 35/1 (March 1953): 9–16. For the medieval debate over the decorum of the Virgin's suffering, see Reindert L. Falkenburg, "The Decorum of Grief: Notes on the Representation of Mary at the Cross in Late Medieval Netherlandish Literature and Painting," in *Icon to Cartoon: A Tribute to Sixten Ringbom* (Helsinki, 1995), 65–89.

52 Tilman Falk and Thomas Hirthe, *Martin Schongauer: Das Kupferstichwerk* (Munich, 1991), no. 27. On Schongauer and his prints, also see Kemperdick, *Martin Schongauer*, 26–161.

53 Schreiber, *Handbuch*, no. 986m; and the entry by Richard S. Field in Parshall and Schoch, *Origins of European Printmaking*, 236–238 (no. 69). On the

Lamentation, see Schiller, *Iconography of Christian Art*, 2: 174–179.

54 "O fliessender prunn der ewigkeit. wie bistu ersigen. O weyßer ler / er der menscheit wie bistu geschwigen. O sunnen glantz ein ewigs / licht wie bistu erloschen. O hoher reichtum wie scheinestu so in gro / ßer armut. O wunne wunniglich wie ist dein antlitz so iemerlich / O liebes kint in meiner sel west ich nit das du es werest. Wie / vnbekant warestu mir. O liebes kint in meiner sele wie bist / du mir gemartert vnd so iemerlichen getodt – Michel."

55 Schiller, *Iconography of Christian Art*, 2: 179–181.

56 On Breuer, see Walter Hentschel, *Peter Breuer: Eine spätgotische Bildschnitzerwerkstatt* (Dresden, 1951); and Susan Ebert, *Peter Breuer: Ein bedeutender sächsischer Bildschnitzer der Spätgotik* (Zwickau, 2003). On German limewood sculpture, see Michael Baxandall, *The Limewood Sculptors of Renaissance Germany* (New Haven, 1980); and Julien Chapuis, et al., *Tilman Riemenschneider: Master Sculptor of the Late Middle Ages* (Washington, 1999).

57 James Clifton, *The Body of Christ in the Art of Europe and New Spain, 1150–1800* (New York, 1997), 88–89 (no. 38).

58 See Roger S. Wieck, *Time Sanctified: The Book of Hours in Medieval Art and Life* (New York, 1988; second edition, 2001), 104–105, fig. 75, 217 (no. 101).

59 John Shinners, ed., *Medieval Popular Religion, 1000–1500: A Reader* (Orchard Park, NY, 1997), 120–122. Shinners reprints a nineteenth-century verse translation by Edward Caswall.

60 "Stabat mater dolorosa / iuxta crucem lacrimosa, / dum pendebat Filius. / Cuius animam gementem / contristatam et dolentem / pertransivit gladius. / O quam tristis et afflicta / fuit illa benedicta / mater unigeniti. / Quae maerebat et dolebat / et tremebat cum videbat / nati poenas incliti" (fol. 78r).

61 "Quis est homo qui non fleret, / matrem Christi si videret / in tanto supplicio / Quis non posset contristari, / piam matrem contemplari / dolentem cum Filio" (fol. 78r).

62 "Eia mater, fons amoris, / me sentire vim doloris / fac ut tecum lugeam" (fol. 78v).

63 The two verses excerpted here include: "Iuxta crucem tecum stare / te libenter sociare / in planctu desidero" and "Fac me plagis vulnerari, / cruce hac inebriari / ob amorem filii" (fol. 79r).

64 On the medieval cultivation of a multi-sensory devotion to Christ's Passion, see Rachel Fulton,

"'Taste and see that the Lord is sweet'(Ps. 33:9): The Flavor of God in the Monastic West," *The Journal of Religion* 86/2 (April 2006): 169–204; Elizabeth Bailey, "Raising the Mind to God: The Sensual Journey of Giovanni Morelli (1371–1444) via Devotional Images," *Speculum* 84/4 (October 2009): 984–1008; and Volker Schier and Corine Schleif, "Seeing and Singing, Touching and Tasting the Holy Lance: The Power and Politics of Embodied Religious Experiences in Nuremberg, 1424–1524," in *Signs of Change: Transformations of Christian Traditions and Their Representations in the Arts, 1000–2000*, ed. Nils Holger Petersen, et al. (New York, 2004), 401–426.

65 Schreiber, *Handbuch*, no. 1013; *Die Frühzeit des Holzschnitts* (Munich, 1970), 9 (no. 23).

66 Carol M. Schuler, "The Seven Sorrows of the Virgin: Popular Culture and Cultic Imagery in Pre-Reformation Europe," *Simiolus: Netherlands Quarterly for the History of Art* 21/1 and 2 (1992): 5–28.

67 Lorne Campbell, *National Gallery Catalogues: The Fifteenth-Century Netherlandish Schools* (London, 1998), 63–66. On related paired paintings by the workshop of Dirk Bouts, see Martha Wolff, et al., *Northern European and Spanish Paintings before 1600 in the Art Institute of Chicago* (Chicago, 2008), 145–151. On paired paintings by Albrecht Bouts, see John Oliver Hand, Catherine A. Metzger, and Ron Spronk, *Prayers and Portraits: Unfolding the Netherlandish Diptych* (Washington, 2006), 40–49 (no. 3); 50–55 (no. 4).

68 Schiller, *Iconography of Christian Art*, 2: 197–224; and Hans Belting, *The Image and Its Public in the Middle Ages: Form and Function of Early Paintings of the Passion*, trans. Mark Bartusis and Raymond Meyer (New Rochelle, NY, 1990).

69 Ingrid Jenderko-Sichelschmidt, Markus Marquart, and Gerhard Ermischer, *Stiftsmuseum der Stadt Aschaffenburg* (Munich, 1994), 105–106, fig. 88. For the attribution to the Master of the Dinkelsbühler Kalvarienberges, see Suckale, *Die Erneuerung der Malkunst*, 2: 37, fig. 762.

70 See Hand, *Prayers and Portraits*, 51.

71 Till-Holger Borchert, *The Age of Van Eyck: The Mediterranean World and Early Netherlandish Painting 1430–1530* (Ghent and Amsterdam, 2002), 254 (no. 81).

72 Charles Sterling, et al., *Fifteenth- to Eighteenth-Century European Paintings in the Robert Lehman Collection* (New York, 1998), 2.

73 Maryan W. Ainsworth, " 'À la façon grèce': The Encounter of Northern Renaissance Artists with Byzantine Icons," in Helen C. Evans, *Byzantium: Faith and Power (1261–1557)* (New York, 2004), 244–555.

74 On the Meteora icons, see Evans, *Byzantium: Faith and Power*, 558, fig. 331.1; and Belting, *Image and Its Public*, 109–115, figs. 59, 60.

75 Belting, *Image and Its Public*, 109.

76 Quoted in Evans, *Byzantium: Faith and Power*, 183–184 (no. 104). See also Maria Vassilaki and Niki Tsironis, "Representations of the Virgin and Their Association with the Passion of Christ," in Maria Vassilaki, ed., *Mother of God: Representations of the Virgin in Byzantine Art* (Milan, 2000), 453–463.

77 See Hand, *Prayers and Portraits*, 51. For prints of the Man of Sorrows, see Parshall and Schoch, *Origins of European Printmaking*, 242–252 (nos. 72–75).

78 For the print, see Max Lehrs, *Geschichte und Kritischer Katalog des deutschen, niederländischen, und französischen Kupferstichs im 15. Jahrhunderts*, 9 vols. (Vienna, 1908–1934), 2: no. 129. For the Master E. S.'s work and career, see Alan Shestack, *Fifteenth-Century Engravings of Northern Europe from the National Gallery of Art* (Washington, 1967), 3–4; and Borchert, *Van Ecyk to Dürer*, 107–111, 293–300 (no. 129–135).

79 Falk and Hirthe, *Martin Schongauer: Das Kupferstichwerk*, 107–111 (nos. 34, 34a); Borchert, *Van Eyck to Dürer*, 318 (no. 151).

80 Barbara Drake Boehm and Jiří Fajt, *Prague: The Crown of Bohemia 1347–1437* (New York, 2005), 8–9, 158 (no. 28). See also Ainsworth in Evans, *Byzantium: Faith and Power*, 548 and fig. 17.11.

81 Hans Belting, *Likeness and Presence: A History of the Image Before the Era of Art* (Chicago and London, 1994), 320–323.

82 Leonid Ouspensky, *Theology of the Icon*, trans. Anthony Gythiel, 2 vols. (Crestwood, NY, 1992), 1: 60–64. On the Lukan images, see also Schuler, "Seven Sorrows of the Virgin," 20.

83 Belting, *Likeness and Presence*, 538.

84 Evans, *Byzantium: Faith and Power*, 246–247, fig. 8.6; Anton Legner, *Ornamenta ecclesiae: Kunst und Künstler der Romanik*, 3 vols. (Cologne, 1985), 3: 169–172 (no. H 69); Christian Wolters, "Beobachtungen am Freisinger Lukasbild," *Kunstchronik* 17/4 (April 1964): 85–91, figs. 1–4 on pages 97–100; and Belting, *Likeness and Presence*, 333.

85 For the inscription, see Evans, *Byzantium: Faith and Power*, 246; and Alice-Mary Talbot, "Epigrams in Context: Metrical Inscriptions on Art and Architecture of the Palaiologan Era," *Dumbarton Oaks Papers* no. 53 (1999): 75–90 (82).

86 In this regard, the scale of the Cummer painting may have specifically referenced the small size of icons like the Freising example, which measures $7^{11}/_{16} \times 5\frac{1}{4}$ in. (19.5 × 13.4 cm). On the importance of scale in fifteenth-century woodcuts, see David S. Areford, "Multiplying the Sacred: The Fifteenth-Century Woodcut as Reproduction, Surrogate, Simulation," in *The Woodcut in Fifteenth-Century Europe*, ed. Peter Parshall (New Haven and London, 2009), 118–153 (130–141).

87 For similar comments on the Lukan icons of Mary, see Belting, *Image and Its Public*, 112.

88 Sarah McNamer, *Affective Meditation and the Invention of Medieval Compassion* (Philadelphia, 2010), 120.

89 Catherine Lutz, *Unnatural Emotions: Everyday Sentiments on a Micronesian Atoll and Their Challenge to Western Theory* (Chicago, 1988), 5. As quoted in McNamer, *Affective Meditation*, 120.

90 Beyond those texts mentioned so far, see also the Franciscan *Meditations on the Life of Christ: An Illustrated Manuscript of the Fourteenth Century*, trans. Isa Ragusa and Rosalie B. Green (Princeton, 1961). For an overview of these Passion tracts, along with a discussion of the impact of German mysticism and the *Devotio Moderna*, see James Marrow, *Passion Iconography in Northern European Art of the Late Middle Ages and Early Renaissance* (Kortrijk, Belgium, 1979), esp. 7–27.

91 McNamer, *Affective Meditation*, 125–126.

92 Ibid., 126–127.

93 See Elina Gertsman, "Introduction: 'Going They Went and Wept'—Tears in Medieval Discourse," in Elina Gertsman, ed., *Crying in the Middle Ages: Tears of History* (London, 2011), xi–xx (xi–xii); and Thürlemann, "Paradoxical Rhetoric of Tears," 64–66. For weeping as a devotional act performed by a man, see Bailey, "Raising the Mind to God," 993, 1000–1001. See also, Moshe Barasch, "The Crying Face," in *Imago Hominis: Studies in the Language of Art* (New York, 1991), 85–99, and notes on 253–254.

94 On the miniature and its effects on our sense of time and space, see Susan Stewart, *On Longing: Narratives of the Miniature, the Gigantic, the Souvenir, the Collection* (Durham, N.C., 1993), esp. 65–67.

95 For a drapery drawing attributed to Michael Wolgemut or his workshop, see Dickel, *Zeichen vor Dürer*, 199–202 (nos. 68r, 68v).

96 Schreiber, *Handbuch*, no. 1937; *Die Frühzeit des Holzschnitts*, 30–31 (no. 83); and Anton Legner, *Reliquien in Kunst und Kult: Zwischen Antike und Aufklärung* (Darmstadt, 1995), 96–97, fig. 29.

97 The display of these relics continues today. Aachen's tunic of the Virgin is in competition with an equally famous relic of her tunic at Chartres Cathedral in France, often referred to as the "Veil of the Virgin" because of its fragmentary state.

98 Martina Bagnoli, Holger A. Klein, C. Griffith Mann, and James Robinson, *Treasures of Heaven: Saints, Relics, and Devotion in Medieval Europe* (Baltimore, 2010), 13.

99 For a thirteenth-century German reliquary once containing several relics of the Virgin's clothing, see Ibid., 90–91 (no. 49).

100 Kemperdick and Sander, *The Master of Flémalle and Rogier van der Weyden*, 291–296 (no. 23), fig. 160.

101 Falk and Hirthe, *Martin Schongauer: Das Kupferstichwerk*, 38–39 (nos. 2, 3); Borchert, *Van Eyck to Dürer*, 321–322 (no. 154).

102 On the Virgin's hair, see Roberta Milliken, *Ambiguous Locks: An Iconology of Hair in Medieval Art and Literature* (Jefferson, North Carolina, 2012), 163–184 (esp. 177–184).

103 Falk and Hirthe, *Martin Schongauer: Das Kupferstichwerk*, 40–42 (no. 4).

104 See, for example, Schongauer's engraving *The Death of the Virgin*, in which Mary still appears youthful, with beautiful long and curling hair. Falk and Hirthe, *Martin Schongauer: Das Kupferstichwerk*, 70–72 (no. 16).

105 Margaret Sleeman, "Medieval Hair Tokens," *Forum for Modern Language Studies* 17 (1981): 322–336.

106 For the Talisman of Charlemagne and other reliquaries that included the Virgin's hair, see Bagnoli, *Treasures of Heaven*, 113, 90–91 (no. 49), 174 (no. 78).

107 M. C. Ross, "Austrian Gothic Enamels and Metalwork," in *The Journal of the Walters Art Gallery* (1938): 71–83 (75–76, figs. 3, 6); and Hans-Jörgen Heuser, *Oberrheinische Goldschmiedekunst im Hochmittelalter* (Berlin, 1974), 159–160 (no. 58). According to the museum's curatorial files, the cylinder on top and the gabled niche are probably part of a nineteenth-century restoration.

108 For a transcription, which completes the inscription's many abbreviations, see Heuser, *Oberrheinische Goldschmiedekunst*, 159; and for a translation, see Ross, "Austrian Gothic Enamels and Metalwork," 76.

109 See Bagnoli, *Treasures of Heaven*; and Cynthia Hahn, *Strange Beauty: Issues in the Making and Meaning of Reliquaries, 400–1204* (University Park, Penn., 2012), 12–14.

110 Schreiber, *Handbuch*, no. 1859 II; *Die Frühzeit des Holzschnitts*, 22–23 (no. 58). See also Claire Richter Sherman, *Writing on Hands: Memory and Knowledge in Early Modern Europe* (Carlisle, Penn., 2000), 64–65 (no. 1). For transcriptions and translations of the texts, see the entry by Sabine Griese in Parshall and Schoch, *Origins of European Printmaking*, 292–295 (no. 92).

111 On the opening woodcuts of hands in the *Schatzbehalter*, see Sherman, *Writing on Hands*, 66–67 (nos. 2A, 2B). On the *Schatzbehalter*, see also Bellm, *Der Schatzbehalter*; and Cynthia Anne Hall, *Treasury Book of the Passion: Word and Image in the Schatzbehalter* (Ph.D. thesis, Harvard University, 2002).

112 Sherman, *Writing on Hands*, 66.

113 On the closing woodcuts of hands in the *Schatzbehalter*, see Sherman, *Writing on Hands*, 153–155 (no. 37).

114 Erwin Panofsky, *Early Netherlandish Painting: Its Origin and Character*, 2 vols.(Cambridge, Mass.,1953), 1: 258. As quoted in Thürlemann, "Paradoxical Rhetoric of Tears,"53.

115 See Wispé, "History of the Concept of Empathy," 18.

62

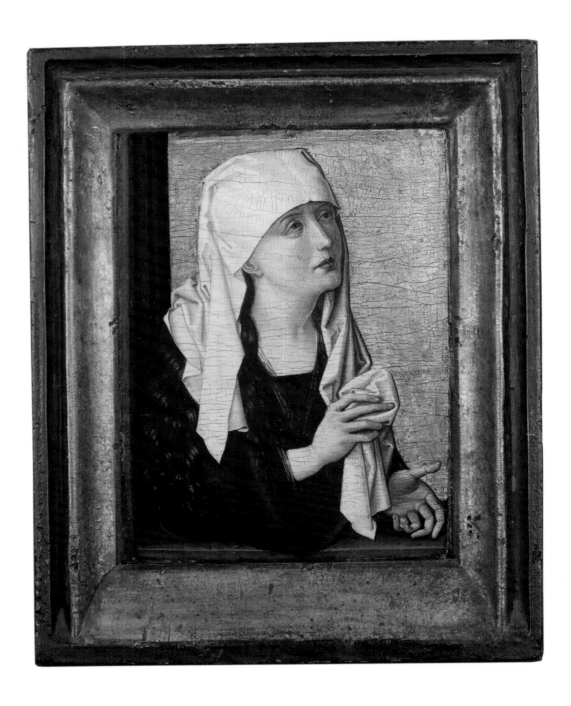

Checklist of the Exhibition

Note to the reader: This checklist records the works included in the exhibition at the Cummer Museum of Art & Gardens. It is divided into two parts according to the order of the objects in the exhibition installation. For the exhibition works illustrated in this publication, a figure number is included after the entry. Dimensions are given in inches and centimeters; height precedes width.

Hands, Hair, and Veil: Meaningful Details

Master of the Stötteritz Altarpiece, *Mother of Sorrows*, c. 1470, oil on panel, image 8¾ × 6½ in. (22.2 × 16.5 cm). Gift of Mrs. Clifford G. Schultz in memory of Mr. Clifford G. Schultz, AG.1984.1.1. The Cummer Museum of Art & Gardens, Jacksonville, Florida. (Fig. 1).

Martin Schongauer, *The Archangel Gabriel*, c. 1485–1490, engraving, image 6⅝ × 4⅝ in. (16.8 × 11.8 cm), 10988 D. Staatliche Graphische Sammlung, Munich, Germany. (Fig. 36).

Martin Schongauer, *The Virgin of the Annunciation*, c. 1485–1490, engraving, image 6¾ × 4¹¹⁄₁₆ in. (17.1 × 11.9 cm), 1005 D. Staatliche Graphische Sammlung, Munich, Germany. (Fig. 37).

Martin Schongauer, *The Little Nativity*, c. 1480–1490, engraving, image 6¼ × 6⅛ in. (15.8 × 15.6 cm), 67333 D. Staatliche Graphische Sammlung, Munich, Germany. (Fig. 38).

Unidentified artist (Southern Germany), *Reliquary of the Virgin and Saints*, late thirteenth century or early fourteenth century with nineteenth-century additions, gilded copper (set with mother-of-pearl, rubies, rock crystal, turquoise and unidentified gem stones), 5⅜ × 5½ × 3¹⁄₁₆ in. (13.6 × 14 × 7.8 cm), 53.27. The Walters Art Museum, Baltimore, Maryland. (Figs. 40 and 41).

Unidentified artist (Germany), *The Hand as the Mirror of Salvation*, 1466, colored woodcut, image 15⅜ × 10⁷⁄₁₆ in. (39 × 26.5 cm), 178913 D. Staatliche Graphische Sammlung, Munich, Germany. (Fig. 42).

Workshop of Michael Wolgemut and Wilhelm Pleydenwurff, *The Left Hand* and *The Right Hand*, colored woodcuts, each image 9¹⁵⁄₁₆ × 6⅞ in. (25.3 × 17.5 cm), Stephan Fridolin, *Schatzbehalter der wahren Reichtümer des Heils* (Nuremberg: Anton Koberger, 1491), fols. e6v and 7r. Acquired by Henry Walters, 91.1086. The Walters Art Museum, Baltimore, Maryland. (Fig. 43).

Unidentified artist (Germany), *The Holy Relics from Maastricht, Aachen, and Kornelimünster*, 1468 or 1475, colored woodcut, 10¹³⁄₁₆ × 14¾ in. (27.5 × 37.5 cm), 118308 D. Staatliche Graphische Sammlung, Munich, Germany. (Fig. 35).

Seeing and Weeping: Passion and Compassion

Unidentified artist (Germany), *Mary as Mother of Sorrows*, c. 1440–1450, colored woodcut, image 10⅝ × 7½ in. (27 × 19.1 cm), 10666 D. Staatliche Graphische Sammlung, Munich, Germany. (Fig. 25).

Master of the Aachen Madonna, *Crucifixion*, c. 1460, colored metalcut, image 15¹¹⁄₁₆ × 10⁹⁄₁₆ in. (39.8 × 26.8 cm). 1951 Purchase Fund, 51.699. Museum of Fine Arts, Boston, Massachusetts. (Fig. 19).

Master of the Starck Triptych, *The Raising of the Cross* [center, left and right panels], c. 1480–1495, oil on panel, center 26 × 19 in. (66 × 48.3 cm) and each wing 25¾ × 9⁷⁄₁₆ in. (65.4 × 24 cm). Patrons' Permanent Fund, 1997.100.1.a. National Gallery of Art, Washington. (Fig. 15).

Martin Schongauer, *Crucifixion*, c. 1480–1490, engraving, image 6⁷⁄₁₆ × 4½ in. (16.3 × 11.5 cm), 140906 D. Staatliche Graphische Sammlung, Munich, Germany. (Fig. 20).

Workshop of Michael Wolgemut and Wilhelm Pleydenwurff, *Crucifixion*, woodcut, image 10 × 6⅞ in. (25.4 × 17.4 cm), Stephan Fridolin, *Schatzbehalter der wahren Reichtümer des Heils* (Nuremberg: Anton Koberger, 1491), fol. 298r. Maria Antoinette Evans Fund, 31.1403. Museum of Fine Arts, Boston, Massachusetts. (Not illustrated; for alternate example, see Fig. 18).

Master of Antoine Rolin, *Pietà*, c. 1480–1490, tempera and gold on vellum, each page 4½ × 3⁹⁄₁₆ in. (11.5 × 9 cm), fols. 77v and 78r. Acquired by Henry Walters, W.431. The Walters Art Museum, Baltimore, Maryland. (Fig. 24).

Michel of Ulm, *The Lamentation with the Virgin, John, Mary Magdalene, and a Witness*, c. 1465–1475, colored woodcut, image 14¹¹⁄₁₆ × 10¾ in. (37.3 × 27.3 cm). William Francis Warden Fund, 53.359. Museum of Fine Arts, Boston, Massachusetts. (Fig. 21).

Peter Breuer, *Pietà*, c. 1490, limewood, 35 × 29¼ × 12 in. (88.9 × 74.3 × 30.5 cm). Purchased with funds from The Cummer Council, AP.1982.1.1. The Cummer Museum of Art & Gardens, Jacksonville, Florida. (Fig. 22).

School of Picardy, *Pietà*, c. 1460–1470, oil on panel, 29¼ × 12 in. (74.3 × 30.5 cm), 1991.22. Sarah Campbell Blaffer Foundation, Houston, Texas. (Fig. 23).

Martin Schongauer, *Man of Sorrows between Mary and John*, c. 1470–1475, engraving on paper shaped to the arched top, second state, image and sheet 7⅝ × 5½ in. (19.4 × 14 cm). Gift of George W. Davison (B.A. Wesleyan 1892), 1952, DAC 1952.D1.8. The Davison Art Center, Wesleyan University, Middletown, Connecticut. (Fig. 31).

Albrecht Dürer, *Man of Sorrows by the Column*, 1509, engraving, image 4⅝ × 2¹⁵⁄₁₆ in. (11.8 × 7.4 cm), 1927:55 D. Staatliche Graphische Sammlung, Munich, Germany. (Not illustrated).

Master of the Dinkelsbühler Kalvarienberges, *Diptych with Christ as Man of Sorrows and Virgin Mary*, c. 1470, tempera on wood, each panel 8¼ × 5½ in. (21 × 14 cm), Inv. Nr. MSA 12576. Stiftsmusuem, Museen der Stadt Aschaffenburg, Aschaffenburg, Germany. (Fig. 27).

Master E. S., *Christ as the Man of Sorrows Surrounded by Four Angels Carrying Instruments of the Passion*, c. 1450–1460, engraving, image and sheet 5¹⁵⁄₁₆ × 4½ in (15.1 × 11.5 cm). George Nixon Black Fund, 34.602. Museum of Fine Arts, Boston, Massachusetts. (Fig. 30).